Painting Portraits
of Children

Simon Davis

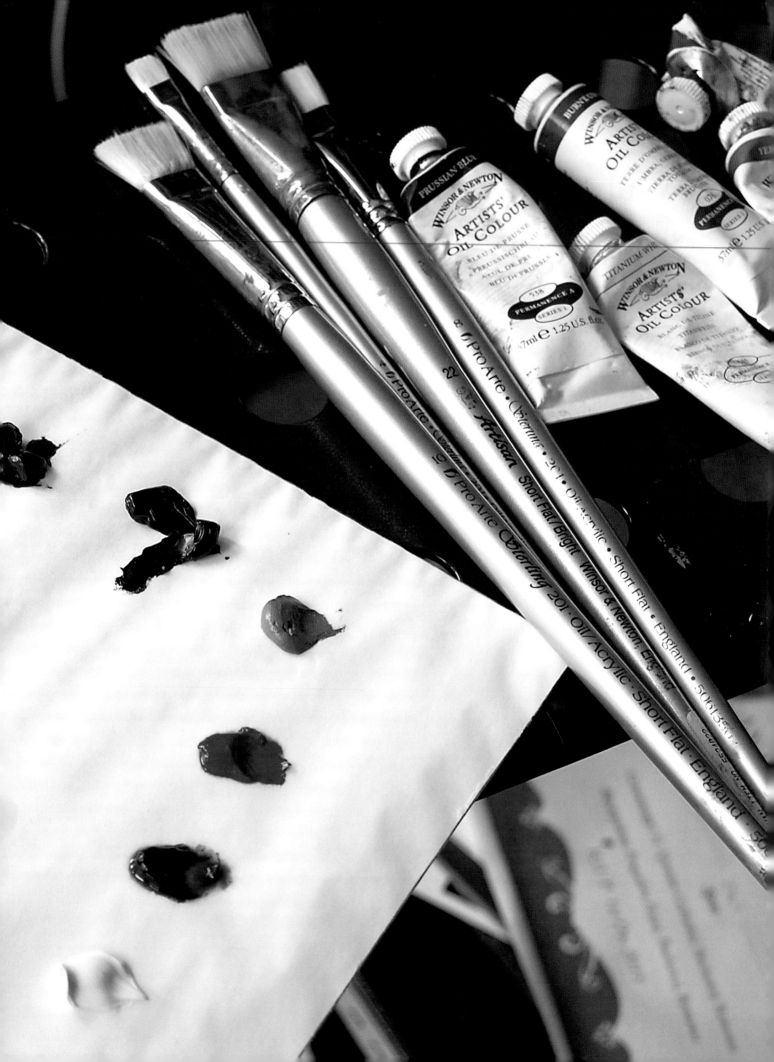

Painting Portraits
of Children

Simon Davis

THE CROWOOD PRESS

First published in 2017 by
The Crowood Press Ltd
Ramsbury, Marlborough
Wiltshire SN8 2HR

www.crowood.com

British Library Cataloguing-in-Publication Data
A catalogue record for this book is available from the British Library.

ISBN 978 1 78500 290 8

Frontispiece: I prefer to use a tear-off palette rather than a traditional wooden one as I find
them very simple and convenient. I try to keep my working practice as straightforward as
possible.

Acknowledgements
I am indebted to the following people who helped with the making of this book: Andrea
and Fiona for their enthusiasm and encouragement; Sophia, Taslima, Haydn, Luke and Arlo
for their patience and tolerance (and the same goes for their parents too); Andrew James for
his generosity with his time and advice and for being very sympathetic when technology
sometimes conspired against us.

For Andrea

Graphic design and layout by Peggy Issenman, Peggy & Co. Design Inc.
Printed and bound in India by Parksons Graphics

Contents

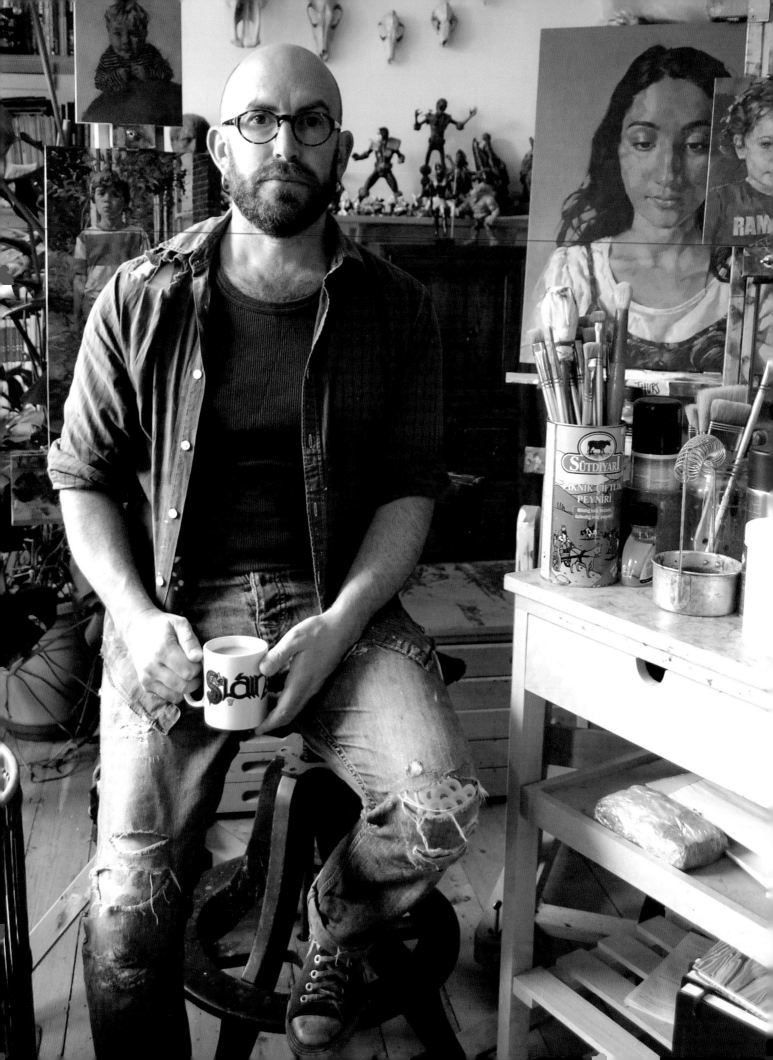

Introduction

Never work with animals or children.

– W.C. Fields

My intention with this book is to briefly outline a subject that can be as simple or complex as you choose to make it. I didn't want this book to be a dry and joyless affair. Painting is generally a frustrating series of titanic disasters and tiny triumphs that either leave you feeling like a miserable failure or a towering genius. Neither, of course, is true. Like any kind of skill or craft, there is no alternative to repetition and hard work and no shortcuts to competence. As with most things, trial and error are often just as important in finding your way forward as success and accomplishment are. Pretty much every painter that I know struggles on a daily basis with the thousands of decisions that a painting demands, so whilst this book can never be a substitute for hard work and perseverance, it can perhaps suggest solutions to common problems and provide a degree of direction in times of uncertainty.

Having said that, as with all forms of portraiture (or indeed painting in general) the success or failure of a work does not always lie in the brilliance of technical skill. The ability to paint well (and some would argue that it is essential) is not the only factor involved in the creation of a good piece of work. Whilst I would never claim to have any great wisdom in these matters, I can perhaps provide pointers that can maybe illuminate, to an extent, what goes into the process that I adopt when undertaking a portrait. To my mind, some of the best pieces of work are done by those that could be considered to be not the most technically proficient painters and vice versa. To me, what separates good from bad is the level of thought and care given to areas such as composition, palette and atmosphere.

Painting portraits of children is often mistakenly considered to be a very simple and straightforward process. There is indeed a lot going for it. The subject can generally be free from any ego and vanity, offer little or no opinion and criticism and will generally have no interest in what you are actually doing or indeed the final outcome. In essence, the perfect scenario. However, there are other pitfalls that easily compensate for this, so being alert to these wouldn't be a bad idea.

The author in his East London studio.

When I first started painting, my early commissions were usually of beloved family pets. Years of indifferent animals, refusing to be compliant soon made me come to the conclusion that if something seems like it is going to be simple, then the polar opposite will be nearer the truth.

In undertaking a portrait of a child, you can easily descend into sentimentality and banality (particularly if the subject is your or a family member's child).

Sentimentality is not always a bad thing, as the innocence of youth can often be captured very effectively in this way. Some of my favourite children's portraiture could be accused of being very sentimental and the obvious example here is John Singer Sargent's *Carnation, Lily, Lily, Rose* (1885-86). In fact it could be argued that it is not really a portrait at all, being more of a painting about childhood. It features Polly and Dolly Barnard lighting lanterns in a garden in Broadway in Gloucestershire. What elevates it above the overly sentimental (apart from Sargent's obvious brilliance as a painter) is its composition and ethereal and magical quality and its lack of obvious formal posing. It captures children being children and showing little regard to the artist or viewer and to me, the painting's success lies in that.

Among the contemporaries of Sargent that I regard as being superlative painters of children are Henry La Thangue (1859-1929), James Guthrie (1859-1930) and George Clausen (1852-1944). These painters are often described as British Impressionists and were integral in my adopting the square-brush style that I invariably paint in. Their subject matter was almost always the depiction of rural life and many of the portraits of working children were without sickly sentiment. As a result they were compelling and provided an alternative view of childhood to those given by the more privileged portraits by the likes of Sargent, Giovanni Boldini (1842-1931) and Philip de László (1869-1937).

There are, of course, many artists whose work I admire for a variety of reasons, be it composition or technique and in Chapter Two I will go into why, for me, their work is worthy of further technical scrutiny.

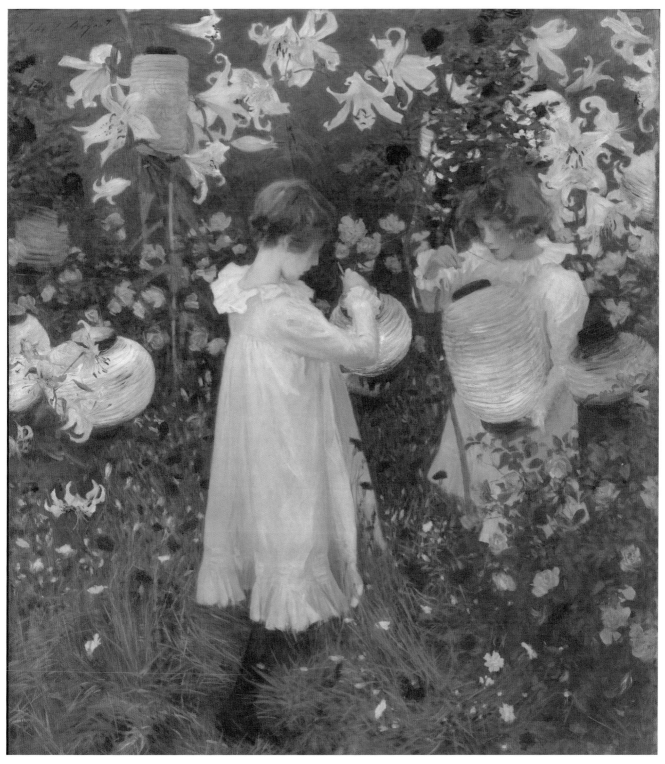

Carnation, Lily, Lily, Rose (1885–6) John Singer Sargent, 1856–1925.
© Tate, London, 2016.

The Studio and Materials

A comfortable space to work in is essential to the creation of work. I have had many different studio spaces over the years, some large and some small. One of the main determining factors to this is the size that you wish to paint. I prefer to paint small- to medium-sized pieces so currently have a relatively modest set-up. I have always made sure that I am able to work from home, be it a room in my house or a separate studio in the garden. A lot of painters rent studios, often with other artists, and this works very well for a number of reasons. The nearness to other artists can be motivational and inspiring so has much to recommend it. However I find that painting where I live works best for me. I cannot emphasize enough the luxury of a very short commute with limited distractions and the flexibility to work when I want. I did once try working in a studio away from my home. It lasted a month.

All the artists I have met work in an array of different studios but always in the environment that is most comfortable for them. There is no right or wrong way of working. Generally speaking large, cavernous studios intimidate me whilst small studios afford me much-needed concentration and focus. A studio with a beautiful view out of the window would be lovely but I fear it would just encourage me to drink even more tea, fuss the cat and procrastinate.

Lighting

It is obviously very important to have good light when working. Overhead northern daylight is preferable as this will provide the best constant light throughout your painting day but this isn't always possible. Therefore, just a good source of natural daylight that allows a tonal consistency throughout your day is the next best thing. If you have to paint at night (this is often necessary when other commitments take precedence) or the daylight you have is limited, there are a large array of studio lighting solutions available. As with most things, these can range from the very expensive and complicated to the very simple. I am fortunate to be able to paint mostly during the day so if an early start or a late finish is required, I just use an energy saving 1900 lumens daylight bulb in the overhead light socket and this is perfectly satisfactory. I also have a table daylight lamp which proves very useful.

Easels

Here again, the ideal easel for you is often governed by the size of painting you are working on and the space you are working in. I generally paint standing up as this allows me to stand back and view my progress from a distance so the most popular solution and the one I use most is the radial easel. These are often made of beechwood and consist of a tripod leg configuration and a sliding upper section. Though not always the most stable of options,

This radial easel is excellent for working on small to medium-sized portraits. It doesn't take up much space and can be folded up for easy transportation.

I bought this beautiful nineteenth-century draughtsman's chair in an antique shop and it's surprisingly comfortable to use. However, I mostly paint standing up as I need to constantly step back and assess the various stages of the portrait's progress.

they are very affordable and versatile and can take very small work or be adjusted to accommodate quite large canvasses. They can also be tilted to suit and can then be folded away tidily when not in use.

Table-top easels are a good option if space is at a premium as they enable you to paint seated and angle your work to suit. For larger work, I use a studio or H-Frame easel. These easels provide the most stability but can often be expensive. There are many different options with varying features from hand-cranks for simple height

adjustment to castors which enable them to be easily moved around the studio. A bit of research will help you find the one best suited to your needs.

To Stand or to Sit?

It perhaps sounds a little obvious to point out that painting standing up and painting sitting down are two very different experiences. I mostly paint standing up because it's easy to do a bit of painting and step back to see if it's any good. Distancing yourself from your work often

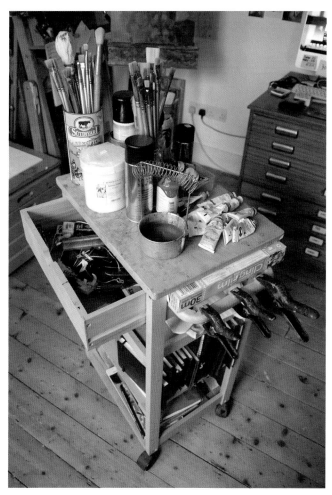

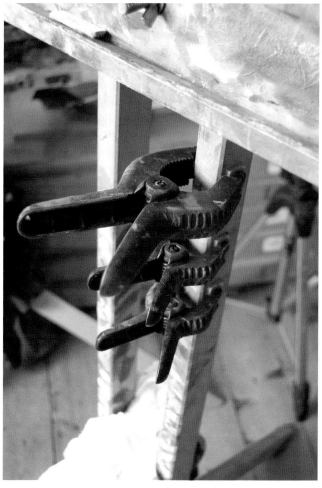

A mobile table trolley is an excellent addition to any studio. It's a perfect place to keep all your painting equipment close to hand and can therefore be trundled round the studio en masse.

Sometimes you become reliant on the most unlikely of things. These clips, bought from a hardware store, have become essential to me. From holding brushes or my palette to clipping reference material to the easel, they really are invaluable.

gives you a valuable perspective and my painting practice involves me constantly stepping backward and forward, to and from the easel.

I do however sometimes have to sit down to paint. When the work is large and I need to paint the lower portion of the work and the height of the ceiling makes raising the easel very high impossible, I have no alternative but to work seated. I found a beautiful nineteenth-century draughtsman's chair in an antique shop and it's surprisingly the most comfortable perch I've ever had.

A Table Trolley

Something I find absolutely invaluable to my practice is having a moveable trolley to hand. I find this to be incredibly useful and versatile and means I am free to move around the studio without having to individually ferry stuff here and there. On this I'll have my brushes, paint,

turpentine and anything else that I deem relevant for what I'm working on and being able to move everything around the studio in one go is nothing short of a revelation. This was a cheap trolley I bought at a DIY store but was just what I needed.

Miscellaneous

Other things that I find invaluable are heavy-duty plastic hand clips. These are available pretty cheaply from hardware stores and have a multitude of uses, from holding brushes to clipping any references you need to your easel. As with most equipment in the studio, the most unlikely things prove the most useful and these clips have certainly proved their worth.

A ready supply of rags and kitchen roll are also useful for mopping up any spillages or, as happens to me regularly, wiping off any painting mistakes.

I always paint on a rigid support so MDF is perfect for this. I prime it with good quality acrylic primer, front and back, and this gives me an excellent surface to work on.

Preparing a board for painting

I begin by very lightly sanding the surface and beveling the upper edges of the side that I'm to paint on. I generally apply three to four coats of acrylic primer with a household paintbrush, allowing a few hours drying time between each. I lightly sand between each coat too so that the final surface will be relatively smooth and even. A useful tip to avoid having to clean the brush during this preparation is to wrap the bristles in cling-film to prevent them drying out.

I always use tear-off paper palettes as I find them simple and straightforward to use. While a lot of painters use palettes that are cleaned at the end of a painting session, I have never really got on with this set-up.

A metal brush holder/cleaner is something I find invaluable too. Maintaining the life of brushes is very important as they are often quite expensive and this simple little device enables you to do this by filling the pot with turpentine or white spirit and simply suspending the brush in it by placing them in the wire coil above.

Materials

Supports

I always paint on a rigid support and find MDF perfect for this. This can be bought relatively inexpensively and cut to whatever size you want at a builders' merchant's.

It comes in a variety of thicknesses and my choice is dependent on the size of the portrait I'm working on. For small and medium pieces, I usually work on 9 or 12 mm thick MDF but if I'm working larger, the weight of the board could make this impractical. A thinner board could be used but a bracing frame should be attached to the back to prevent the board from warping and creating an unsuitable painting surface.

Primer

I use an acrylic primer to prepare the boards for the paint. Using this primer excludes the need to initially seal or 'size' the board. After trying out various brands, I have settled on one produced by C.Roberson and Co. This provides excellent coverage and a superb surface to work on. I paint three to four coats onto the front and sides of the board and very lightly sand between each coat, so that there is only a slight 'tooth' to the surface. Although probably not always essential, I also put one coat on the reverse of the board to prevent any warping, however slight, which can often happen even with very thick panels.

Brushes

I paint using the 'square-brush' technique which involves the paint being applied in a blocky, unblended manner. The brushes I use for this are oil/acrylic short flat brights. I favour the synthetic types (usually the Pro Arte Sterling series) as they apply the paint evenly and keep their sharpness and shape for a long time. I try to not to go too small with brush sizes as this can, by its very nature, encourage too much detail which is something I try to avoid.

The 'square-brush' technique

Basically, this technique introduces a blocky, structural quality to the painting and builds up the surface with a distinct and decisive jigsaw-type appearance. Therefore there is little or no actual blending of the tones so, to a large extent, it relies on the viewer to visually mix and unify the image as a whole. The artists whose work I greatly admire and were great proponents of this technique were Frank Bramley (1857–1915), Stanhope Forbes (1857–1847) and George Clausen (1852–1944). For such a very bold and decisive technique, it can also be a surprisingly subtle way of applying the paint. Brushstrokes can be used directionally to suggest form and different blocks of colour can sit side by side to create a unifying tone.

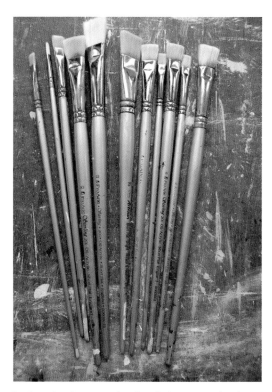

I paint using the square-brush technique so use brushes called short flat brights. I favour using the synthetic variety as they keep their sharpness really well. However, to extend their life, a thorough cleaning after each painting session is essential.

Paint and Palette

I work with a very straightforward palette as above all else, I desire simplicity in my work and these colours provide all that I need. I use the Winsor and Newton Artists' Colour range and they are predominantly earth colours, rich in pigment and versatility.

- Burnt Sienna
- Yellow Ochre
- Burnt Umber
- Cadmium Red
- French Ultramarine
- Titanium White
- Prussian Blue

Mediums

Again, with my work, I really value simplicity so all I add to the oil paint as I work is a small amount of an acrylic resin medium called Liquin. It speeds the drying time of the paint and also is excellent for smoothing out the paint flow.

Cleaning up

I use turpentine substitute to clean brushes after use and then finish this by washing them in water and washing-up liquid. Sometimes I find this part is often a real chore but doing it thoroughly will extend the life of my brushes and it can often become a nice ritual to end my painting day.

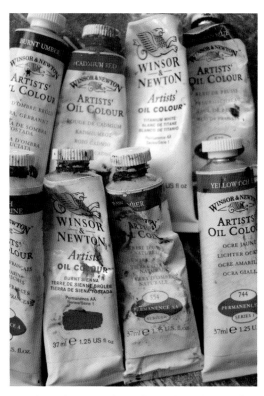

My colour palette is made up of a very limited range of paints. I find that from these colours I can mix everything I need.

Preparation

There are many ways to approach the start of a portrait and this is usually governed by whether it is commissioned or non-commissioned. The latter is obviously the simplest as you can pretty much do what you want and the only person you need to satisfy is yourself.

With commissioned work things can become a little more complicated. The commissioners usually are the parents and, quite naturally, may have strong ideas as to what they want. You are about to interpret in a portrait the most precious part of their lives, and nobody knows the subject like they do.

I have never really had any problems with this as long as from the outset it is understood that this is a *painted* portrait rather than a school photo, so any of the usual rules of the latter generally don't apply. I often meet with a client prior to undertaking the commission just to allay any fears or misconceptions as to what I plan to do. Of course I want to make the client happy but (and this may seem obvious) they are also commissioning a painting by me, in my style and with my way of working. This sounds like I'm being a little defensive but it's not my intention to make it sound that way and as with most commissions, it's a process of discussion and openness that leads to a good outcome all-round.

I also have a few loose rules that I try and stick to.

Preliminary thumbnail sketches are essential to my process as, even though the final portrait will inevitably change, having at least an idea for a composition always helps. I also take a lot of photo reference and work from it back in the studio.

- I do not like subjects to smile in paintings. This is quite counter-intuitive in portraits of children as they are, by definition, generally considered beacons of light and energy. Smiling to my mind gives the impression of frivolity and spontaneity most associated with snapshots and, as I said before, this is a painting, so a degree of gravitas is desirable. I personally try not to be sentimental about the painting of children. I want to be sympathetic of course but I think the most successful child portraits are approached in the same way as any other portrait: with thought and intelligence and honesty.

- For the purposes of the following demonstrations within this book, I will approach them as though I were embarking on a commission so that I can illustrate the same thought processes and ideas that I have when working commercially.

- After the initial meeting with the commissioner of the work and the sitter, I will hopefully be better able to draw up my plan of action. Generally speaking, this usually happens at their family home. This is the ideal as it relaxes the parents and the child feels comfortable in his or her environment and it gives me a very helpful opportunity to spot any suitable backgrounds or compositions for the portrait.

- A plan will then be made for me to visit again to take photographs. All my portraits are painted from photographs. In the world of portraiture, the use of photography probably throws up the most divisive arguments, so I'll just outline a few of my thoughts on the matter.

The Use of Photography

I have always used photographs as an integral part of my process of painting. However, like any other tool used within painting, it is just that, *a tool*. It is vital to me but I am always aware that I must never become a slave to it... or I endeavour to never become a slave to it, that is.

A photograph in the process of my painting is just information, pure and simple. It is not the portrait, composition or tonal solution. It provides much more information than I could possibly need and as a result needs to be seen through a filter, as it were. I am not a hyper-realist painter and have no desire to be. To my mind, a painting must be more than the simple copying of reference material. To me, what elevates a painting from good to great are the following factors:

- Composition
- Atmosphere
- Tonality and palette

With commissioned work, I don't particularly subscribe to the argument that I should be able to paint a portrait that gets to grips with the subject's character and reveals some hitherto hidden personality trait. I generally don't know the subject personally and as a result, my understanding of them is always going to be limited. This does change though when I do paint someone I know well as other factors inevitably intrude into the process.

Photography when painting children, I find, is absolutely essential. I have no idea how some of history's great portrait painters ever painted children without it. As most will know, trying to get a child to sit still for a minute, let alone hours is nigh on impossible. I can only imagine the threats and tantrums and tears that would have ensued... and that's just the artist... goodness knows how the child would have behaved.

So to me, photography is a great aid to the whole process. It's quick, simple and encourages informality and a relaxed result.

I try to spend at least an hour or so photographing the subject. This has a number of benefits. The simplicity of this process varies with the age of the child of course as an older subject is more willing to sit still or look this way or that. A younger sitter can often be a little more problematic. Generally, in my experience, the younger children find the process of having photographs taken exciting for about the first quarter of an hour and you are confronted with smiles, performance, laughter and the big show tunes from *Annie*. After this, things descend into another phase when your presence is barely acknowledged and you become an annoyance. This is mostly when the best reference is gathered. When a child is distracted or even bored, that is generally when they are at their most natural and relaxed.

Compositional Roughs

I don't really keep a sketchbook per se but I do like to jot down compositional roughs and ideas. This usually takes place in the time between the initial meeting with the subject and the taking of the photos, when I have an idea of how the child looks and the environment in which the portrait is to be set.

I use a small Moleskin watercolour sketchbook as I find it easy to use. A compositional sketch is really a simple process that can range from a box and the loosest of watercolour stick figures, to a fairly complex idea of what you wish to do. Although doing a sketch at this stage is often an exercise in wishful thinking, the reality of actually being with the subject often inevitably means you change your plans or hopefully a better solution makes itself apparent. Whilst not set in stone, it does give me a degree of comfort that I have at least some idea of what I'm actually going to do and have a point of reference to discuss with the client.

As an example of this, I've made a few quick breakdown sketches of children's portraits by other painters that I particularly admire, and explain briefly why I think they are so successful. Examining composition like this is an important and useful way of realizing that, regardless of the technical brilliance of the finished piece, the portrait's real success lies in good composition and balance.

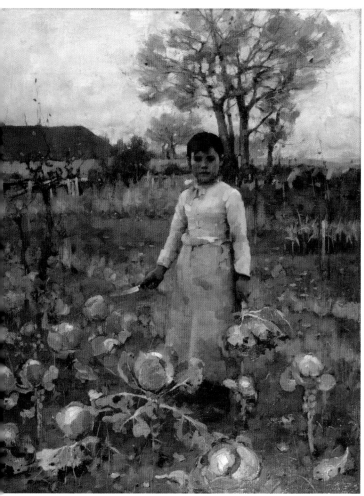

A Hind's Daughter (1883), Sir James Guthrie, 1859–1930,
© National Gallery of Scotland.

A Hind's Daughter, Sir James Guthrie (1883)

This is a beautiful painting that hangs in The Scottish National Gallery in Edinburgh and is a great example of the kind of earthy, naturalistic work that was being produced by a number of painters around the turn of the nineteenth century. The girl is the daughter of a farm labourer (a hind) and looks squarely at the viewer, in a break from her work cutting cabbages. To me, the success of this piece lies in the verticals (the tree and the girl) and the horizontals (sky, hedge, field and barn) being perfectly judged and harmonious.

The child holding the sharp knife also adds a degree of incongruity to the piece. The reality of a child involved in what must have been very hard and tiring work would have challenged the metropolitan art critics' perception of childhood.

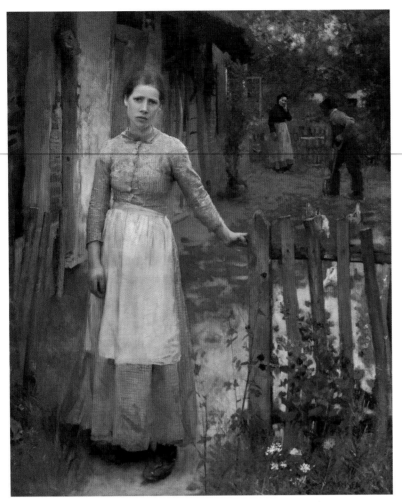

The Girl at the Gate (1889), Sir George Clausen, 1852–1944, © Tate, London, 2016.

The Girl at the Gate, Sir George Clausen (1889)

I must say that this is one of my favourite paintings. It hangs in Tate Britain in London and to me represents the coming together of great painting, composition and social meaning. It's a great example of 'rural naturalism' and again the dominance of the vertical shapes make this a compelling piece. The girl's indecision as to her future is beautifully conveyed by her restlessly looking out of the painting, with her hand loosely holding onto the threshold gate while her parents convey the worry that her decision to leave would inevitably bring.

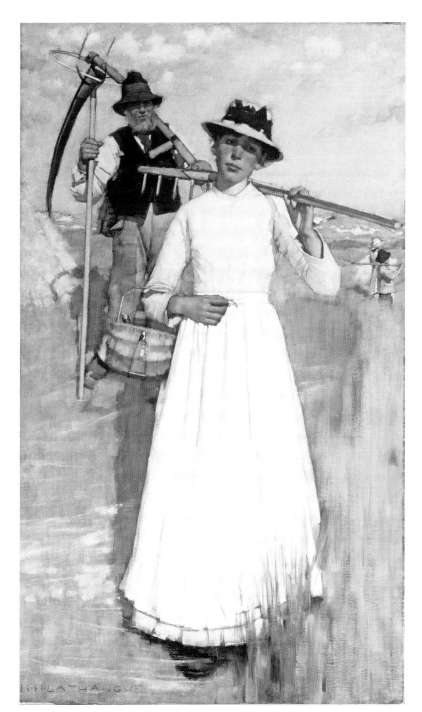

The Return of the Reapers (1886), Henry Herbert La Thangue, 1859–1929,
© Tate, London, 2016.

The Return of the Reapers, Henry Herbert La Thangue (1886)

This painting, also at Tate Britain in London is a beautifully painted work and a great example of the square-brush technique. It almost looks like a stained-glass window composition, with large areas of flat colour yet on closer inspection, the paint surface is beautifully subtle and tender. The palette used really does convey the heat of working outdoors and there is a tiredness to the figures that I love. Once again, there is a one third/two third divison of the sky and land and some really interesting diagonals produced by the scythe and rake.

Portrait of Erich Lederer, Egon Schiele (1913)

I think Egon Schiele was truly a genius. For one so young, his understanding of the human body and the human condition was astounding. This portrait really is a charm-ing study of the young boy and shows that Schiele was just as capable of portraiture that was playful and tender as he was in his more visceral and challenging works. There is a lovely flow and structure to this piece with the lower left to upper right diagonal being used to great effect.

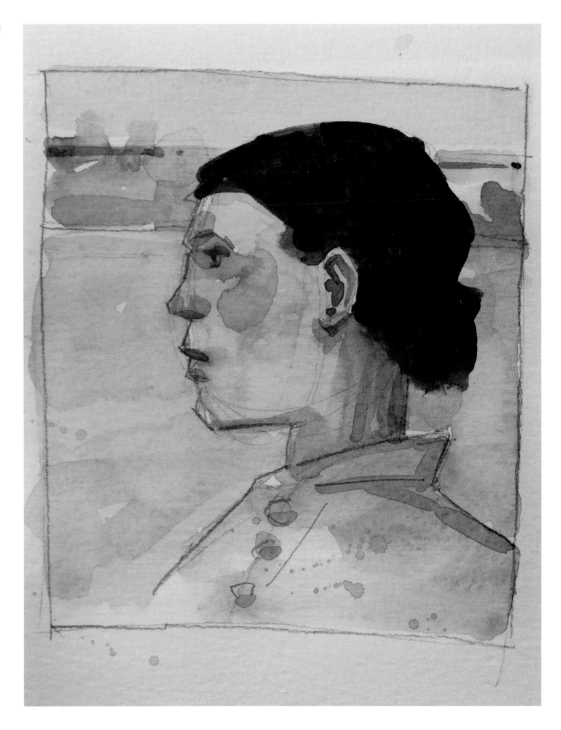

Girl's Head, Sir George Clausen (1887)

This beautiful profile portrait is in the Towner Gallery in Eastbourne. Unlike the previous Clausen painting discussed here, this is a very simple composition but also a very striking one. The girl's hair and face are the focus of the piece leaving the background to shift subtly from sky to grass to earth and then to the girl's shirt. The gorgeously painted ear is central to the composition and really ties it all together.

The following few chapters are concerned with the step-by-step process of painting a portrait. Each chapter deals with a different subject and looks at how my decisions regarding size and composition may differ depending on age and gender of the subject. I approached each demonstration as though they were commissions so that I could shed light on my thought processes and decision making.

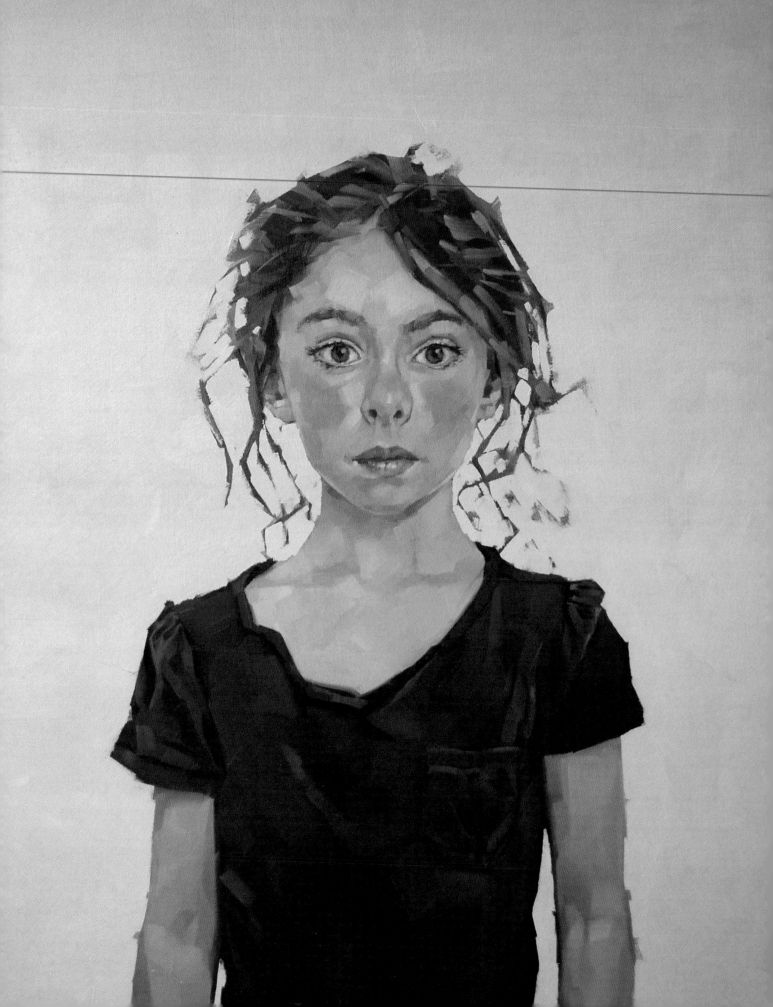

Sophia

(age six)
24" × 20" Oil on Board

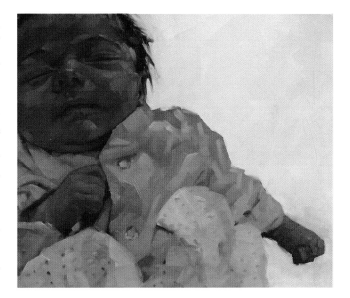

In principle, painting a portrait of a new-born baby should be a relatively simple affair. In my experience, painting a very young infant can be a difficult and testing experience. Obviously, at this young age, infant features are unformed and, forgive me for saying it, slightly generic. This does produce some difficulties as when painting a portrait, a degree of personality and form is always helpful for a painter and generally at this age, that is hard to find. Therefore, a compositional solution is often useful. Illustrated here is a portrait of my niece, Sophia, that I did when she was aged about two weeks. I felt that this composition (that was completely unplanned) leant itself to this landscape format and the absence of a background gave the overall piece a very pleasing 'shape'.

A few years later, I thought it would be a good idea to tackle a portrait of Sophia as she is now, aged six. As she is a member of my family, I have a helpful amount of familiarity with her and her personality which isn't the case with most commissioned subjects. What is astounding to me is quite how much her features have changed at this age. Her features have started to become more defined and from my point of view, as a painter, this gives me more scope for the portrait.

I started this portrait with a very simple idea in mind. I wanted the composition to be very plain and, if I could, use the proportions of the board to emphasize Sophia's size and the simplicity of childhood.

Sophia, 24" × 20" oil on board 2016. Above all, I wanted this portrait to have a strong compositional 'shape' to it and have a lot of space around the figure.

When I took the photos of Sophia, I tried to adhere to my original idea. Of course other compositions suggest themselves all the time during this part of the process but unless I feel that they are superior to my original, I discard them. As with all my portraits, I am operating the 'no smile' policy. I want, if I can, to make this portrait quite thoughtful and sparse. I choose a day when the light is very flat and therefore the shadows are not too overpowering.

Once I have gathered together all the photographic information that I need, I begin by preparing a piece of 24" × 20" board in the usual way.

In this case, as it is a fairly manageable size, I have opted for a 12 mm thick wooden panel as that will provide the stability that I need.

As I previously said, I wanted the proportion of the figure within the painting to convey the size of the subject so I drew up the image of Sophia so that her eyeline is roughly in the centre of the panel, leaving a lot of surrounding space, particularly at the top.

I now am ready to transfer the image onto the primed board. There are many ways to do this. For example, you can square up the reference image and do the same on the board and transpose the image that way. Projecting the image onto the support is also another option and is particularly useful with larger images. I simply trace the image down after enlarging it to the desired size with a photocopier. There was a part of me that used to feel a bit guilty about this as it is a very clinical and functional procedure but I like to have a very accurate line to work from and this is what works best for me.

Finding a process that works for you is very important and I don't know any artist who doesn't have their own idiosyncratic way of working. All that really matters is the finished image, so how you reach that is entirely up to you and personally speaking, I am not such a purist that I would rule anything in or out to achieve this.

I began as usual with a very simple thumbnail sketch.

Sophia is now old enough to take an active interest in what's happening and to a degree can understand what I'm trying to achieve. We decided that she would leave her hair and clothing exactly how they were on the day. I personally find it far more interesting to see a sitter portrayed informally as this is how they look most of the time and therefore is probably a fairer reflection of them and their personality. This isn't a school photo where neatness and formality apply so it is liberating for both myself and the subject that this kind of tidyness is actively discouraged.

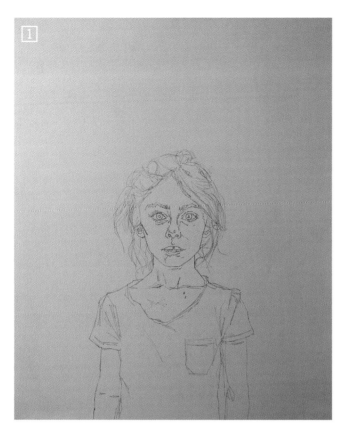

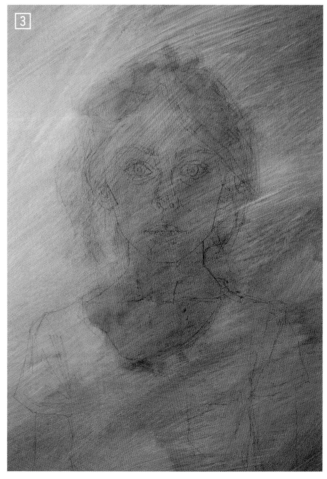

Day One

1 I produce a very simple yet precise drawing on the board and it is at this stage that I can really see the proportions and features of the face in their most basic form. I find this stage very useful as it can often inform what I decide to concentrate on during the painting stage.

2 I begin by applying a thin acrylic wash or *imprimatura* over the entire board.

3 The pigments used are Raw Umber and Ultramarine which, when combined, give a pleasing coldish mid-tone to the composition. As this is an acrylic wash, it will dry quickly and allow me to commence painting very quickly.

I begin by laying a thin overall layer of Burnt Sienna and Burnt Umber on the area I am to paint so that it will mix with the subsequent paint layer as I'm working. It's difficult to quite explain why I do this but this wet layer does mix, to a degree, with the subsequent paint that I will apply in this session and I like to think that in some way this will 'harmonize' these initial stages of the portrait.

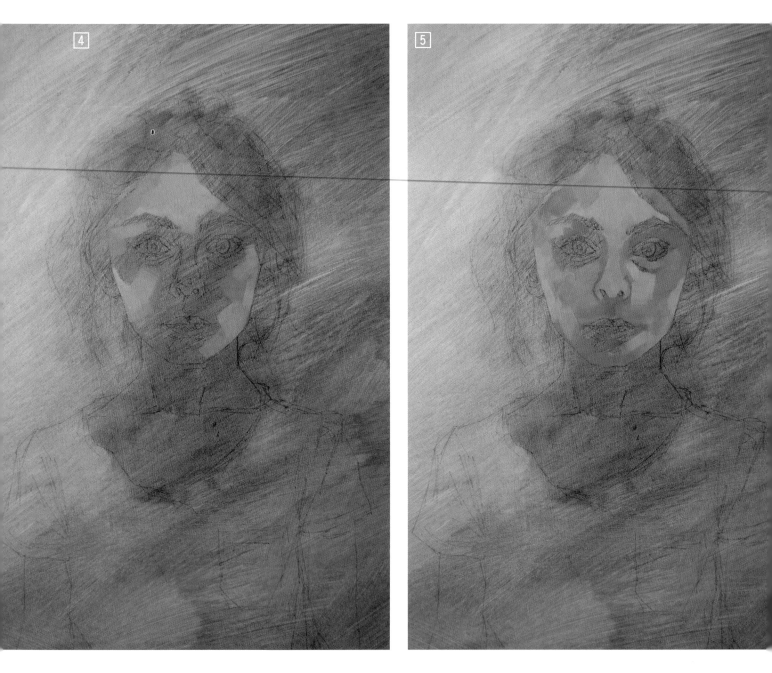

[4] I begin with the lighter areas of the face (forehead, cheeks and so on) as I find this the easiest way to work and 'find my way' into the portrait.

Because Sophia's complexion is pale, tonal shifts are often very slight so care needs to be taken and attention must be given to the overall temperature of the composition.

[5] With this in mind, I often make black and white photocopies of the source reference I am using as this is a very quick and useful way of understanding the tonal range of the face. Here again, this kind of mechanical aid could be considered one shortcut too far but I see it as simply gathering more information and that can never be a bad thing. I use Cadmium Red, Ultramarine, Yellow Ochre, Prussian Blue and Titanium White at this stage and block in the areas with a fairly broad brush and with quick, energetic strokes to get the initial paint layer down as quickly as possible.

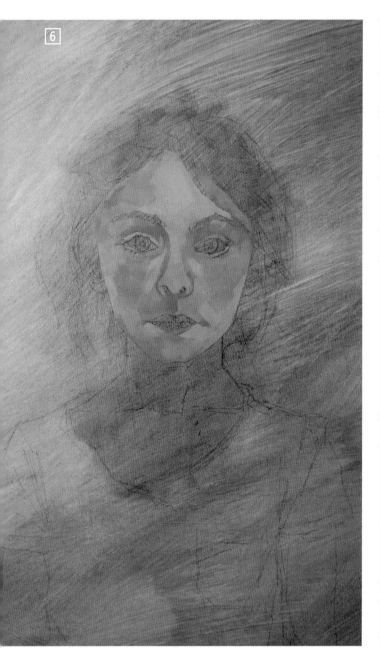

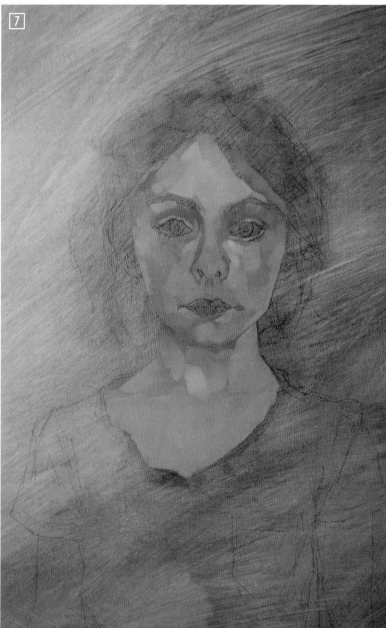

6 Accuracy and likeness are not that important to me at this stage of the portrait and I will begin to introduce pigments that will not necessarily be relevant to this layer of the painting process but will make a little more sense when they have dried and the next layer is overlaid.

7 As I become happier with the face, I will move onto the neck area. This is a particularly important part as the skin is very thin and delicate here so decisive yet subtle brushstrokes are required.

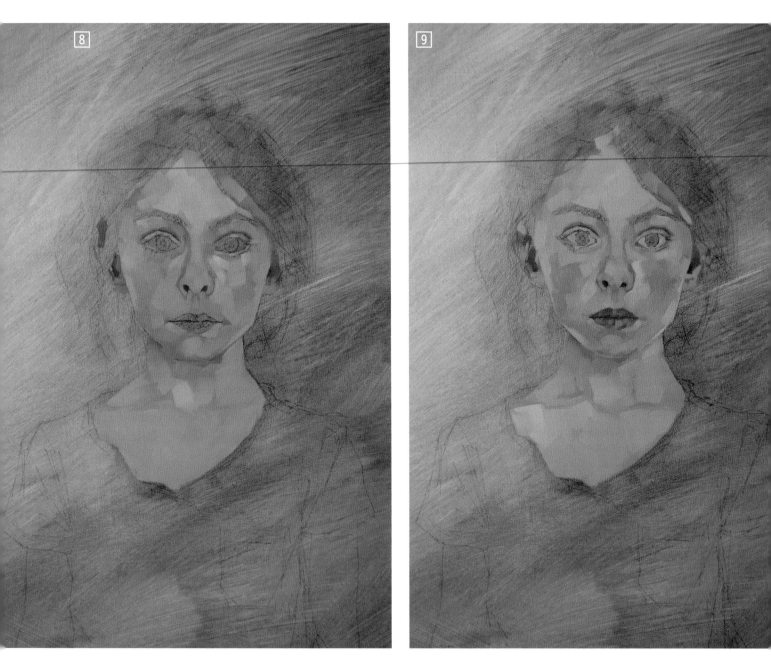

I now start to work into the darker tones of the face, for example the ears, and also pay a bit of attention to getting the eyes and lips blocked in. It is here that the importance of a solid drawing as a foundation pays dividends. To have an accurate drawing underneath that is always there, provides much needed reassurance and if any paint needs to be removed (which often happens), then reapplying it is a straightforward process.

9 As the form starts to take shape, I continue to add basic moulding to the lips and the eyes. Here I block in the whites of the eyes using Prussian Blue and Titanium White. There is a lot of blue in this part of the eye, and to reflect that, I can perhaps exaggerate it a little. At the heart of the painting process, there can be a kind of visual freedom that encourages optical colour mixing rather than literal accuracy.

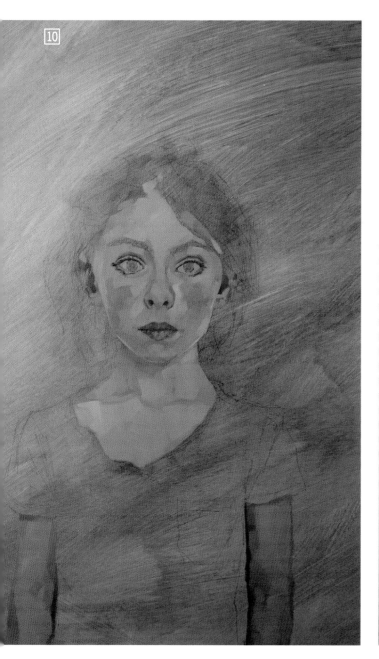

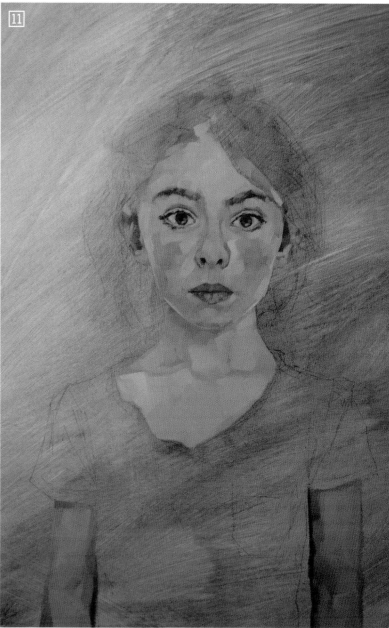

10 As the skin tones are already mixed on my palette, I block in the arms very quickly. Large brushstokes can be used but an understanding that the skin tone of the arms will be different to that of other areas of the portrait. In day-to-day life, arms are more exposed to the sun so therefore have a different tone to that of, for example, the neck.

11 The eyes and eyebrows are worked into a bit more and it is here that the likeness and overall portrait begin to take shape. Working into wet paint at this stage affords a blending that can often be both subtle and defining. Sophia's eyebrows are quite a strong feature but there are areas of them that are not as dense so the wet paint enables me to blend them with the skin tone beneath and hopefully achieve a more natural effect. The pupils of the eyes are added but here again, this is done quickly to avoid these early stages becoming too static and lifeless.

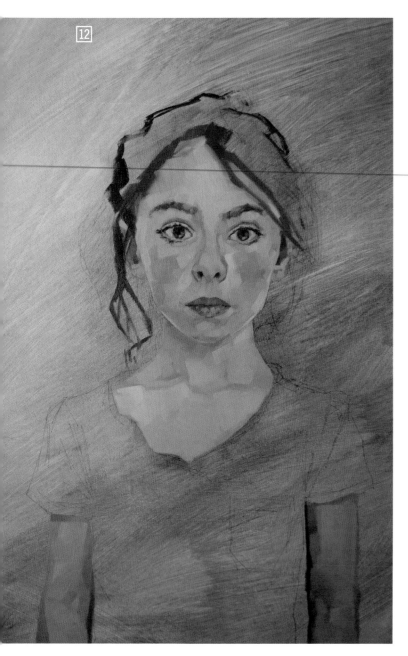

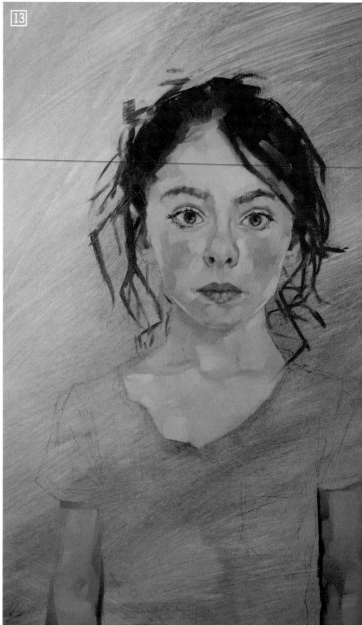

12 I'm quite happy with the skin areas of the portrait at this stage so will now leave it and move onto the hair. The outline is quickly painted in and the colours used in areas such as the hairline are also introduced.

13 Sophia's hair is a mid-brown but strong pigments can be introduced to shadow areas or the hairline. A mix of Cadmium Red and Ultramarine are used here and these quick strokes mix with the wet skin tones and suggest a more believable relationship to the previously applied paint. The hair is painted in using a mix of Burnt Sienna, Burnt Umber and Prussian Blue and highlights are achieved by adding a little Yellow Ochre.

14 When I took the photographs at the start of this process, I wanted Sophia's hair to be just as it was on the day and not tidied up. I wanted her playfulness to be suggested

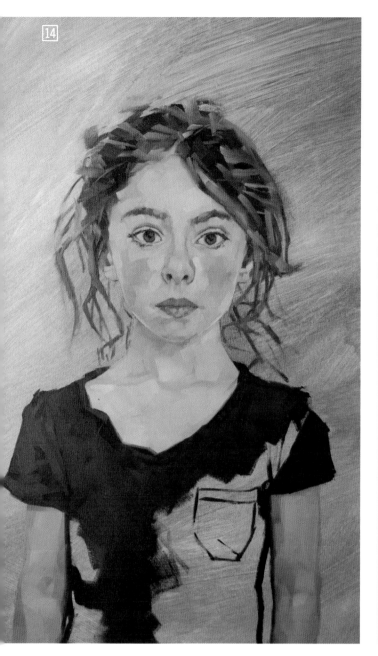

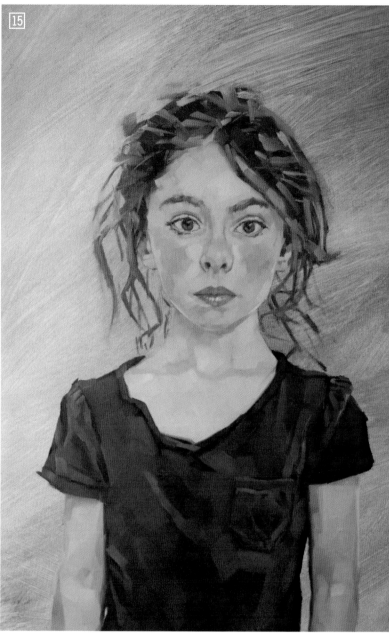

by this and at this stage of painting, I can really block it in very rapidly and quite messily. Later, when I get to the stage of filling in the background, the shape of the hair will be cut in by it, so once again, what I am painting now has an awareness of what I intend to paint later.

I tend to work around areas of the composition in a quite systematic way which could be considered a little clinical but I find it not as overwhelming as building the complete image up equally and at the same time. At this stage, and after a few more rough ochre and blue highlights to the hair, I feel it necessary to begin the blocking in of the shirt.

15 Again I do this in a very quick way and using a fairly large brush so as to maintain a little more energy in the paint. The shirt colour is a mix of Prussian Blue, Burnt Umber and Cadmium Red. I've never been particularly worried about getting an exact colour match in comparison to the reference photographs as I feel that would be yet another chain that would shackle me to the tyranny of the photograph. The success of the piece all depends on how it all ties in together in the painting, so liberties can and should be taken. Once I've added a few heightened areas to the shirt, to suggest folds and volume, I feel that the first day is at an end so I'll leave it for a few days before I come back to it.

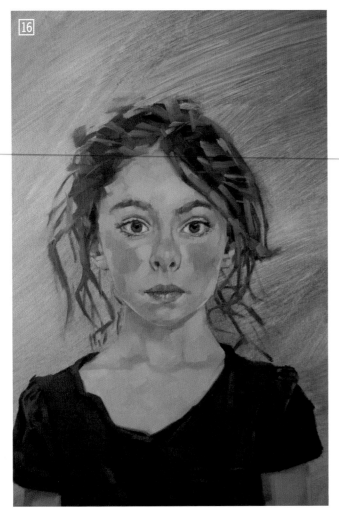

Day Two

[16] Now that the first layer has dried to the touch, I can better assess where I am in the whole process. The paint seems to have dried in quite a coherent and even way so I decided, as is often the case, that I don't want to work on it too much as I would lose the clarity and freshness of this initial layer. One of the skills that will hopefully be developed during a painter's life is the ability to know when something is complete or there is a freshness to the painting that would be spoilt if it were to be added to. Sometimes there is an unconscious guilt associated with speed and ease where a painting is concerned; that unless a painter really struggles and wrestles with the process then it is in some way a lesser statement. Sometimes this kind of tussle is the case but I find that often, painting quickly and without too much care can produce some really unexpected and pleasing results. I have ruined a lot of paintings because of my inability to stop meddling and failed to realize when something is complete and further work would subtract rather than add... it's one of the hardest skills to master and, to my mind, sometimes much more difficult to fathom than the physical act of applying paint.

So, on this second day of painting, I add a minimal amount to the face. Perhaps a little flick of Prussian Blue to the cheek or a dart of Cadmium Red to the ear.

[17] Now that the figure is at a stage that I'm comfortable with (though it may or may not be complete), I can begin the blocking in of the background. This is a deeply encouraging and enjoyable stage as for the first time, the intended composition emerges and hopefully everything starts to pull together.

I wanted a light background that would push the figure forward and emphasize the delicacy of the subject. I also didn't want there to be any variation in the tone of the background either so would have to mix enough

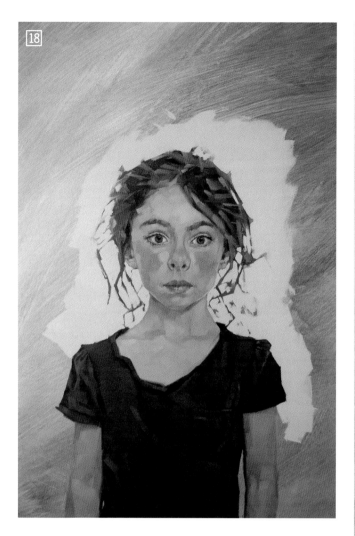

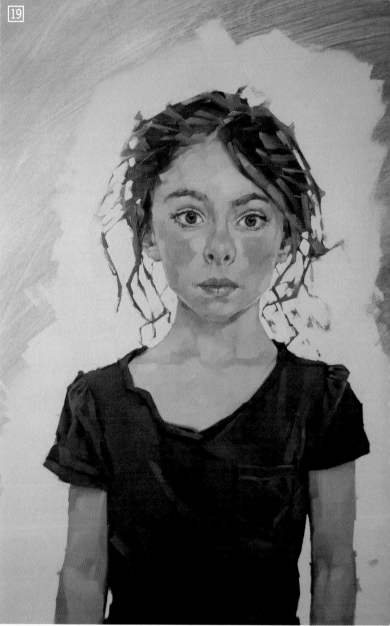

paint to ensure a uniformity of colour. I did this by mixing Titanium White, Burnt Umber and a little Prussian Blue on a palette, using a palette knife. This procedure takes a little time as it's a constant balancing of the different colours until I feel that I have the tone that I'm after.

Once this is done and with a mid-sized brush, I begin to fill in the background.

18 I vary the direction of the brushstroke so that a sort of patchwork of blocks is built up.

19 Squaring up an outline that in reality is rounded and organic is a very pleasing discipline and its crispness can be used to convey energy and life. In this case, I am fairly careful when forming the shape of the face as even a slight inaccuracy can lead to a surprising loss of a likeness. I have spent many hours stood in front of the easel, trying to work out what is wrong with a portrait I'm working on and why it's gone wrong. This can be as a result of the smallest of things: sometimes even a single brushstoke and it often requires an almost forensic examination to find it... but once it is found and it is corrected, the change is often quite incredible.

The underlying acrylic wash becomes very integral at this stage as I can block in quickly and the accidental gaps that appear randomly can be left and indeed add to the building up of the paint surface. I work in a systematic way around Sophia's outline and once that is done then I fill in the remainder of the background.

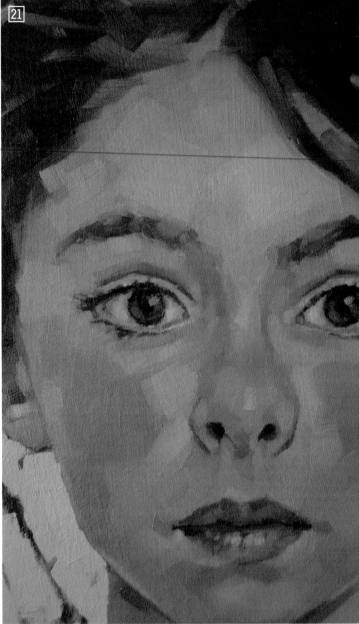

[20] There is a degree of going back over the outline and perhaps I may blend certain areas and add flashes of blue and red.

That is the end of day two on this portrait so I'll leave it for a few days and come back and see where I am.

Day Three

[21] After the paint surface is dry to the touch I can better assess what stage the painting is at. To be honest, I'm not entirely sure that it needed a lot more work so I simply added a few highlights to the eyes and nose. This seems like a straightforward thing to do but it is important to take care as badly applied highlights can unbalance the painting and shift the viewer's focus to a part of the face that is perhaps not intended.

[22] So once that is done and I feel that anything else would be detrimental to the portrait, I put down by brush and head for the kettle.

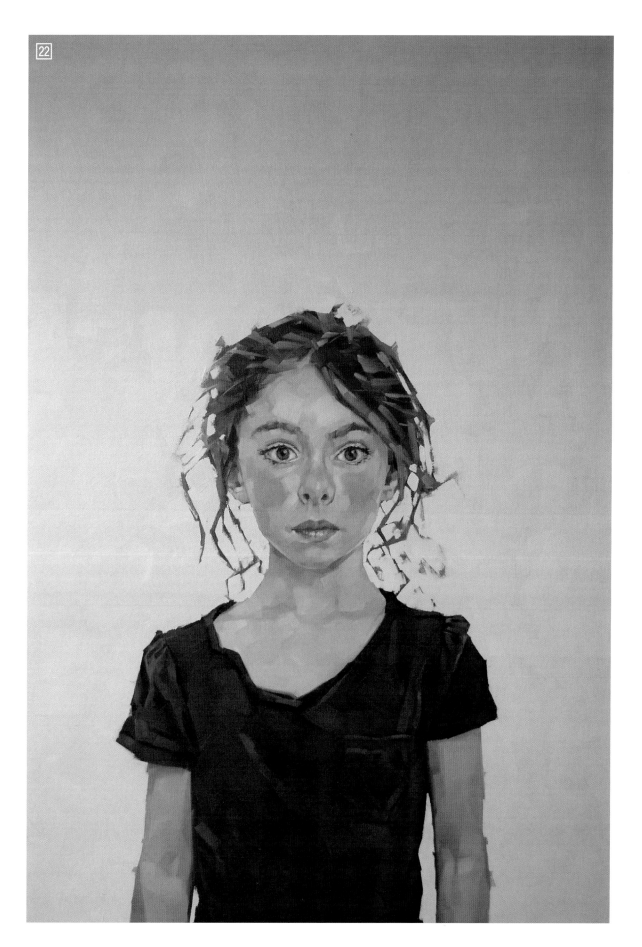

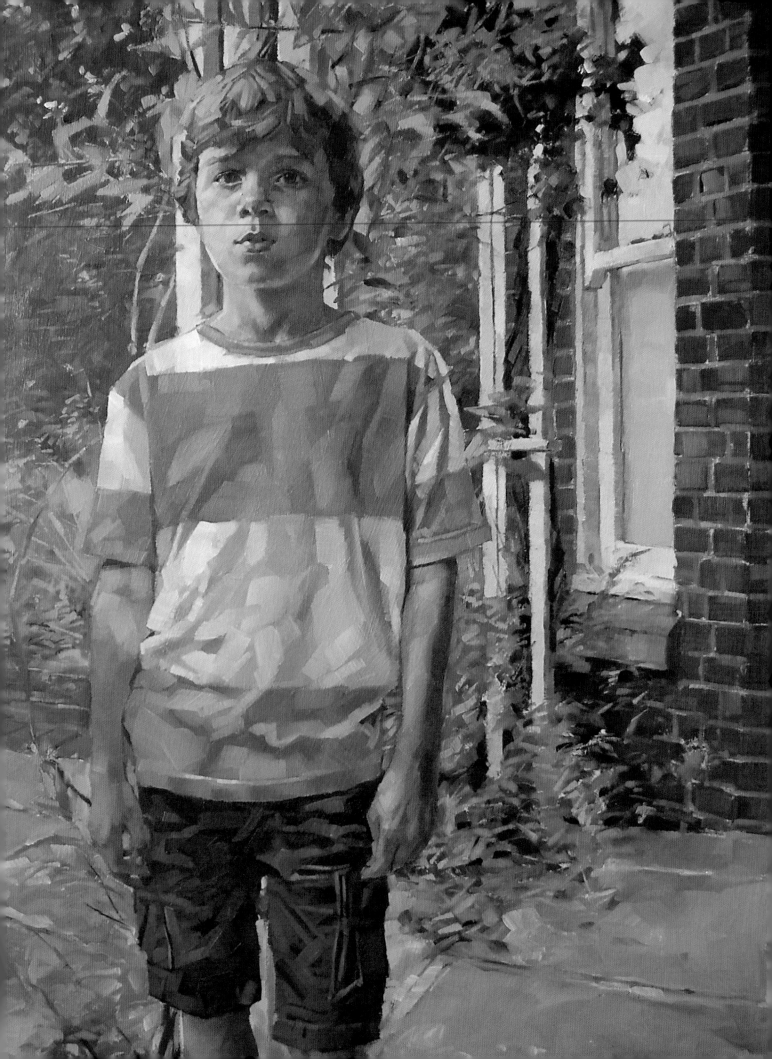

Haydn

(age seven)
21" × 12" Oil on Board

With this portrait I wanted to show how the dimensions of the board I'm painting on can be used in a very effective way. I decided on a narrower size which would lend itself to a full figure portrait. Also I wanted to have more of a background or environment to this piece too. Haydn is the son of friends and they live in a beautiful manor house in Worcestershire. This I felt would make an excellent backdrop to the portrait as I wanted to reflect Haydn's rural childhood and home life.

As I was relatively familiar with the environment that I wanted to set the portrait in, I made a quick thumbnail sketch that would hopefully be helpful when it came to showing Haydn and his parents what I was planning to do.

The actual detail of this sketch was kept vague as I didn't want to be tied to it but it was the kind of composition that I was after so I felt it helped me to visualize how the portrait could look.

Having a background like this would be challenging as it was texturally quite varied (brick, foliage and so on) and treatment of these different surfaces would need to be reflected accordingly.

Setting this portrait in a small corner of the family garden would perhaps be a way of recording Haydn's childhood and place him there at his current age and height so in years to come when looking at the portrait, it would hopefully bring back memories for him of a particular time in his life.

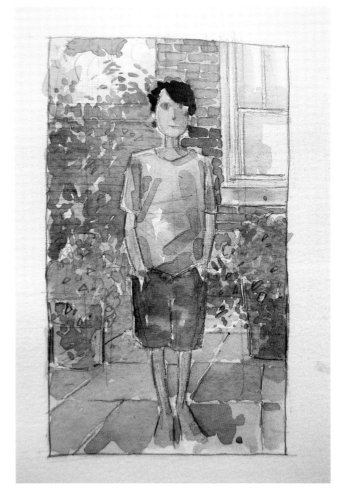

Haydn, 21" × 12" oil on board 2016. There is a strong vertical aspect to this composition, with the figure, wrought-iron posts and the window being ideally suited to a narrower portrait.

I spent quite a time taking the reference photographs, trying various locations within the garden until I settled on something that I thought would work. As the dimensions of the portrait I wanted to do were a little taller and thinner that usual, I thought it would be be an interesting idea to include a lot of vertical lines to the composition. Outside the rear of the house, there is

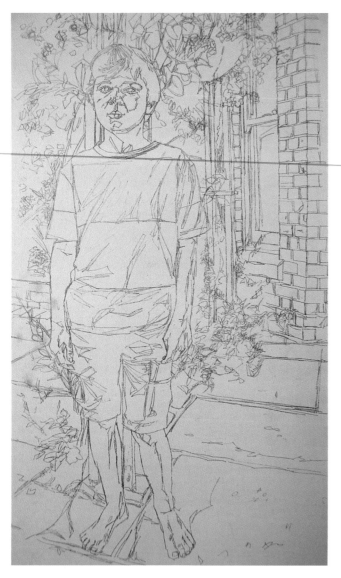

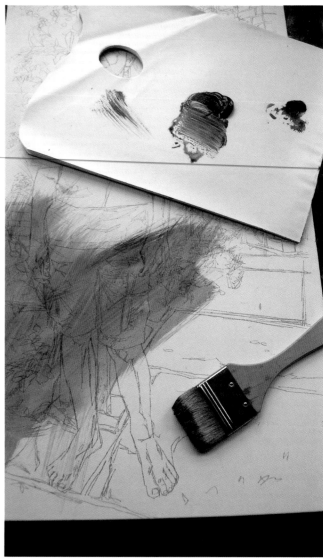

a lovely wrought-iron frame around which a grapevine grows so I wanted Haydn to be stood near this with the sash window behind. I thought this was a good short-hand to describe the house and its character, whilst also including elements of the established garden too.

On returning to the studio, I transferred the relevant elements for the portrait to the board that I was to paint on. A useful thing about having a fixed element as a background (in this case the white wrought-iron post) is that it is a constant throughout the reference photos that I have taken; elements can be harmonized relatively easily so that everything is to the correct scale within the composition.

The mid-tone *imprimatura* is applied and this time I have used a larger mix of Umber than Ultramarine as I wanted the underlying tone to be earthy so as to reflect the outdoor setting of the piece.

This is applied quite thinly with a broad brush and I don't worry too much about how consistent it is as the reason for it is purely to provide a base tone to work from, rather than being an integral part of the final work. I'm a great believer in trying to maintain a level of energy throughout each stage, so even in the initial phase, that principle is applied here too.

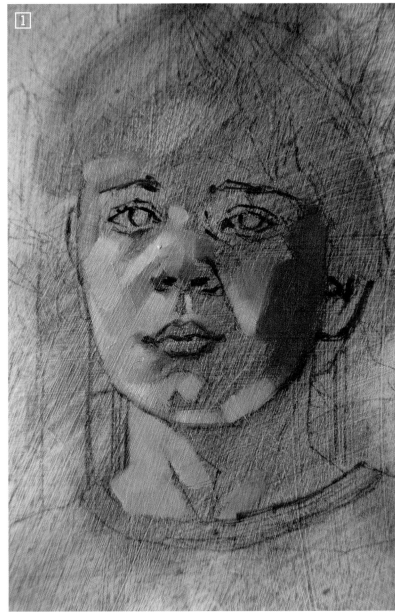

Day One

1 This portrait presents a few practical problems that are absent in the other portrait examples in this book in that the actual figure is somewhat smaller within the composition. It seems an obvious thing to say but this means that a smaller size of brush is used and there is a level of concentration and precision required so as not to 'lose' the drawing beneath and lose the actual likeness.

Therefore, the building up of the face is done at a slower and more considered pace and to make sure that the important facial features are not lost, I emphasize the underlying drawing with some fine lines in a mixture of Cadmium Red and Prussian Blue.

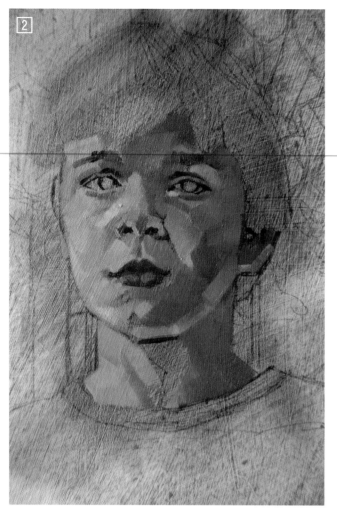

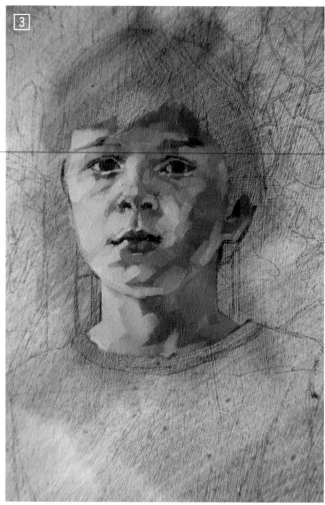

2 I generally start with the lighter tones on the face (using Yellow Ochre, Prussian Blue, Cadmium Red and Titanium White) and then work those into the shadows so as to gradually build form and depth.

The overall size of the face that I'm painting is only about 5 cms squared so the possibility of losing my way with an imprecise brushstroke is always there. Mistakes are, of course, regularly made but these can be removed by simply wiping off the paint, safe in the knowledge that the underlying drawing remains untouched.

3 I'm continuing to build up the face by blocking in the eyes, nose and mouth. I'm trying not to get too distracted by achieving an absolute likeness at this stage but just aiming to get those elements more or less in their right place. Things begin to make sense when the hair is blocked in as this gives the face a greater degree of form, recognition and gravity.

The right tools for the job

Most of the painters I know employ tools in their practice that could often be considered eccentric and not exactly what they were designed for. Mine is the humble earbud.

They are incredibly useful when I need to remove paint in a very precise way, especially when I'm working quite small and I don't want to disturb the paint layer too much.

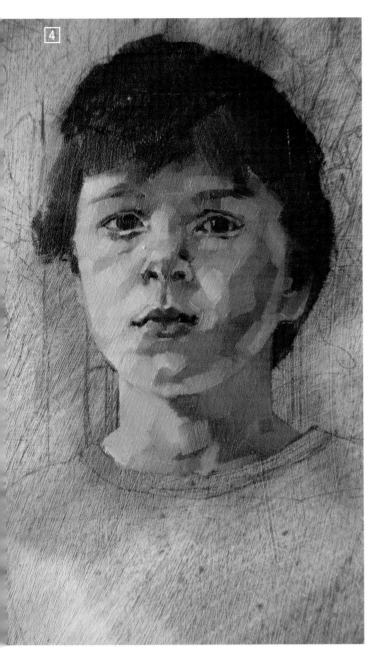

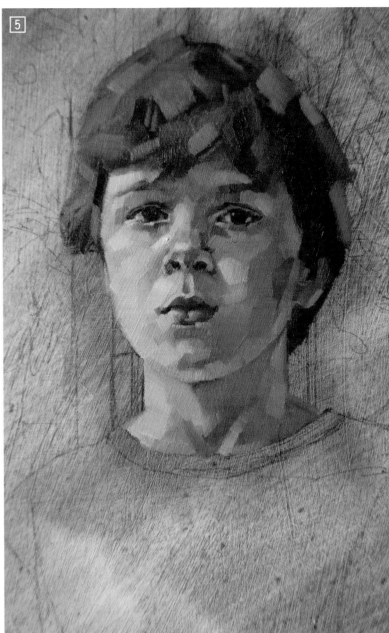

4 The hair is worked into slightly so that the head becomes a little more coherent and 'readable'.

5 At this point, and more than is usually the case, it is important to know when to stop and leave the painting at a stage that I'm happy with. The temptation to keep working has the potential to ruin any good work that has been achieved... a *very* difficult thing to learn... if in fact you ever *do* learn it... but it never hurts to try.

So at this stage, I decided to finish working on the head. It's neither good nor bad and sometimes that's all that can be hoped for on the first pass.

6 Next, I move onto the arms. I tend to work on the areas of skin tone first so that the palette I have previously mixed for the face can be used again. That said though, the skin tone on the arms (and later, the legs) is slightly different to the face as exposure to (or lack of) the sun changes it in a very subtle but important way that can be reflected in the application of the paint.

The paint is applied with a slightly larger brush as there is a greater freedom when painting the arms. It is generally painted in a vertical manner although horizontal blocks of Prussian Blue are applied to the delicate area at the tops of the forearms.

7 It is desirable to try and be accurate but also not to worry about getting things entirely correct. When painting in stages, it is a good idea to keep the next paint layer in mind so that you don't try and do too much with this one. It can be maddeningly frustrating to knowingly leave a painting in a state that you feel is unresolved but patience is always a virtue in this case.

8 To maintain the shape and form of the hands, I outline them with the dark colour of the shorts and blend the edges so I can then leave them and move onto the legs.

9 I put a thin layer of Burnt Sienna over the area to be painted as this sometimes helps with the application of paint.

10 The feet are generally speaking hidden from the sun for most of the year so their tone is lighter and more delicate. Prussian Blue is an excellent pigment to sparingly add to the mix as this gives an impression of luminosity that delicate skin has.

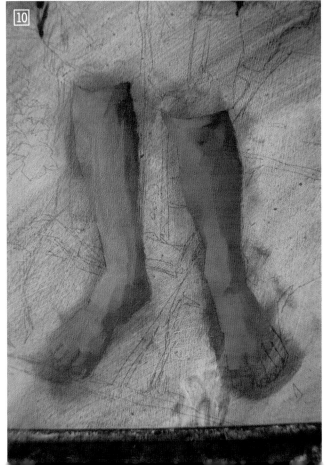

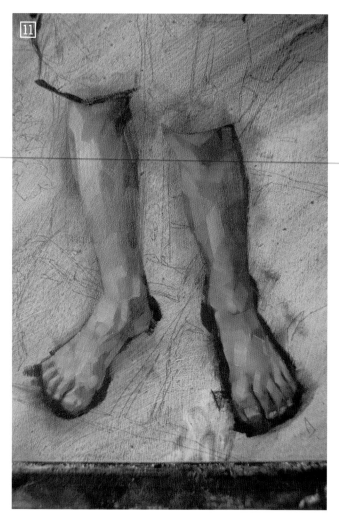

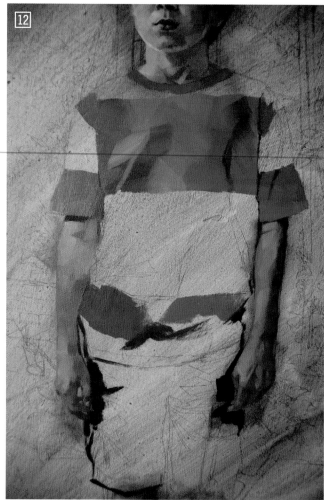

11 The legs and feet are worked into a little more, with brushstrokes being applied in different directions to bring shape and form and to perhaps add energy.

12 I next move onto the clothing. This affords a lot more freedom and to accentuate folds and creases in the shirt, a larger brush is used. This applied in a lot of overlayed strokes, applied quickly and relatively precisely.

13 The shirt's grey stripes are painted by mixing Burnt Umber, Prussian Blue, a little Cadmium Red and Titanium White. The white stripes are painted with Titanium White and a little Prussian Blue. This gives the material a very fresh appearance and the blue is perfect for subtle shadows and shifts in tones.

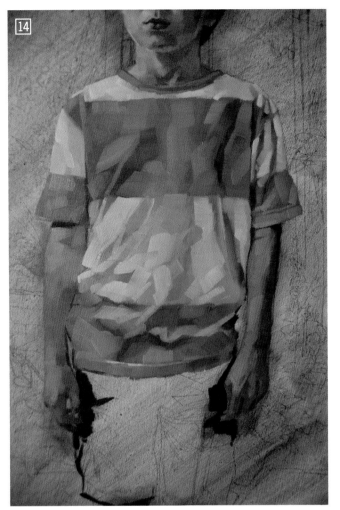

14　Once the shirt is blocked in, it can be blended to a degree, so that form is suggested. It has to be remembered that this shirt has a body inside it so that volume should be reflected in the shadows and tonal shifts.

15　The final painting on day one is the blocking in of the shorts. Prussian Blue, Burnt Umber and a little Titanium White are used and as this is the final piece of the initial figure block-in, it is a pleasing and encouraging part to end on.

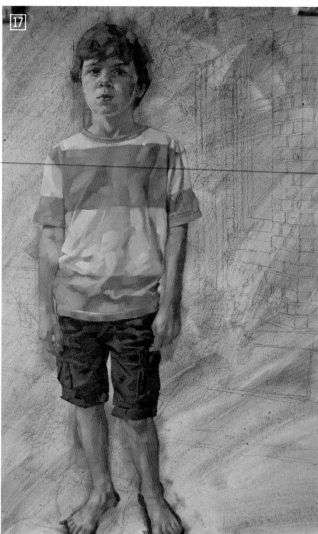

16 Any kind of contrast (in this case the dark shorts against the shirt) really brings things into focus. In reality, depth and form occurs through light, shade and colour rather than line so when these elements start to harmonize in the figure like this, you really do feel progress is being made.

17 So by the end of day one, I have blocked in (with varying degrees of accuracy) the figure. I will now leave this to dry for a few days and return to do the initial pass over the background.

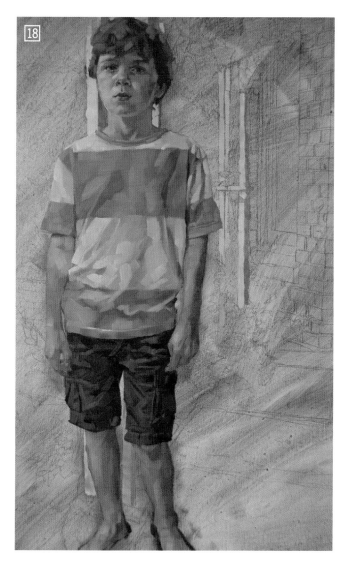

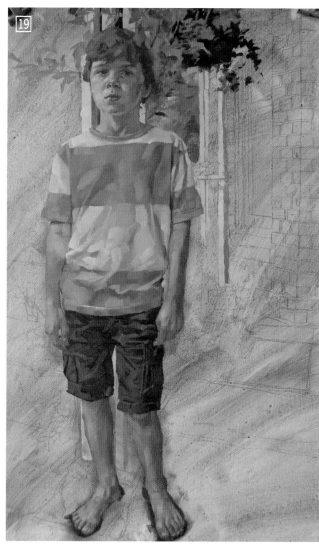

Day Two

[18] After leaving the portrait to dry for a few days, the paint layer has to a degree harmonized and 'settled'.

When starting a background, I usually look for an 'in', as it were. I have to begin somewhere and this is usually something in the background that is compositionally binding to the whole piece. In this case I have chosen the upright wrought-iron pillars that support the vine as it runs through the vertical nature of the composition and enables me not to lose where I am in the blocking in process and provides a feature that I can come back to if I feel I am getting a little bogged-down and confused. I begin by loosely painting in the verticals, trying to follow the underdrawing reasonably accurately but also quite quickly so as not to get too over-detailed. Any mistakes can be rectified in the next layer.

[19] Once this is done, I can move onto the foliage. I predominantly paint this with a mixture of Prussian Blue, Permanent Green Light, Winsor Yellow Deep and Titanium White. I'm not worried at this stage about colour accuracy as I'm not quite certain quite how detailed I want the background to be. That is one of the many things about painting I like. There really are no rules as to how you should treat various aspects of paint application as it really is an ever-changing process that means that I can decide to work in a detailed way or opt for a more vague, almost impressionistic way.

To me there is almost a compulsion to get paint down onto the surface of the panel as quickly as I can, so the paint is almost applied in an agitated and frenetic manner.

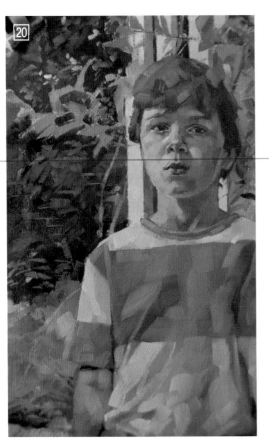

20 There is not that much definition in what I'm painting at this stage but I try to use the square-brush marks to give the impression of leaves and foliage. I continue this busy round of blocking in the background and enjoy being able to cut in quite sharply to the previously painted figure.

21 Along the way, I start to introduce flashes of Cadmium Red for the flowers and berries, again as a way of tying in the background to the reference photographs that I have.

The Burnt Umber and Ultramarine acrylic *imprimatura* really helps in a composition such as this. This background tone enables me to leave gaps in the paint layer, allowing it to show through and, as it's sympathetic to the composition, bind it together and give it a unity that a pure white ground would perhaps not do.

Next I move onto the brickwork using Burnt Sienna and Burnt Umber.

22 I generally use a brush that is a suitable size to paint a single brick in one stroke, angling it to suit the differing perspectives. The window frames are now blocked in simply and then, in turn, the glass.

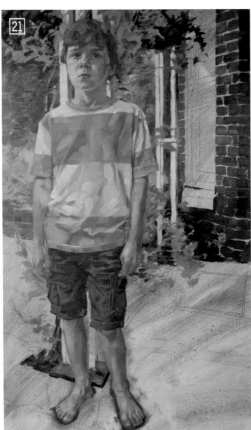

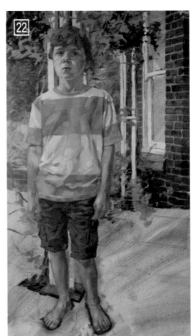

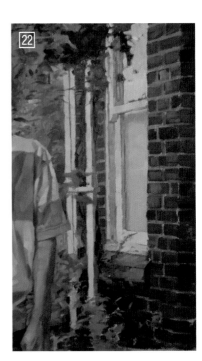

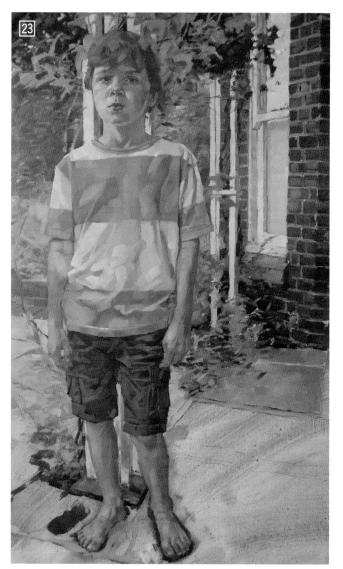

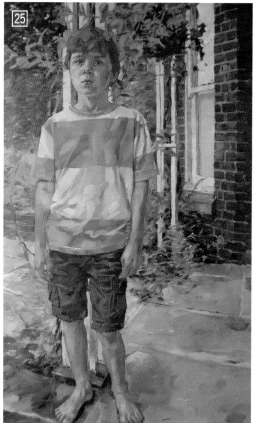

[23] It's still all a bit vague but things are at least starting to suggest a little depth and form. For example, the painting of the window pane has really pushed forward the shape of the hanging basket and therefore a sense of space is created.

The slabs that Haydn is stood on can now be given some attention too. It is important to establish a gravity to the figure as it's very easy to ignore this and not anchor it within the composition.

[24] I don't want him to appear like he's floating about so the solution to this is found in a number of ways. Most obviously is by applying shadows beneath the feet and then shifting tonal values between the slabs in the foreground and those below the window. The cutting in around the feet is done rapidly using the square-brush edge to give a clean, energetic edge.

[25] This marks the end of day two. I'll leave it to dry for a few days so it will tonally unify with the previously painted figure layer.

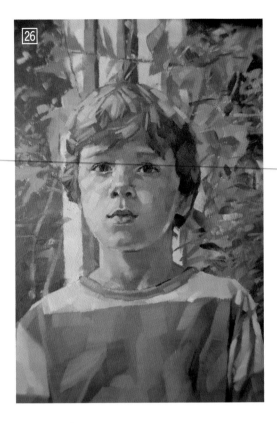

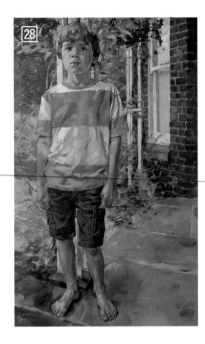

Day Three

26 For the next pass over this portrait, I will be concentrating on getting a likeness and generally tightening up the image. As it's the focal point of the portrait, I begin with the face.

27 The initial paint layer now appears quite crudely applied so I will spend time giving this some attention. During the first stage I was keen not to lose the geography of the face so had been quite precise and as a result, had not had a chance to apply decisive brushstrokes for fear of obscuring the underlying drawing. Now that that layer is ready to be added to, I can paint in a little less uptight way. I add highlights to the hair and cheeks and am careful to push out the lighted side of the face so as give the head a more three-dimensional appearance. I may, at a later stage, apply a glaze to the shadowed areas but I won't be sure if this is necessary until this paint layer has dried. I then move onto the legs and feet – I am already using a flesh tone palette so this will give a degree of cohesion with the face and arms. I add a highlighted area to the top of the feet and then add shadows between the toes and under the instep to add weight and volume. I really try and make a concerted effort to make the figure look like it has a heaviness to it and belongs in the painting.

28 To be honest, there isn't much that I want to add to the figure at this stage so I add a few highlights to the shirt and shadows to the shorts.

29 Moving onto the background, I start by adding some dark shadows to push out the foliage and create a sense of depth and space.

These do look a little crude but as they dry, they will bed in a little more. It's difficult sometimes to keep in mind that a fresh paint layer does look a little incongruous with the previous one and have faith that the drying process will harmonize this. I add a few fresh green highlights to the foliage in a very simple and quick way. Not too detailed but enough to indicate different varieties of plants and once again, suggest depth and push the figure to the fore. I work into the brickwork and window too and just add some highlights to add form to the different surfaces and textures.

A level of tonal balance is desired within the composition so while I am keen to work into the background detail, I don't want it to become overly complex. The primary focus of the painting is Haydn so I don't want to draw attention away from him. I like that there is interest elsewhere in the picture but hopefully the spirit of my initial composition won't be lost.

This is the end of this painting day so I'll leave it to dry and then come back to it and see what needs to be done. It is important not to overwork it. I would rather work on it very gradually than do too much and lose any good work that I had done before.

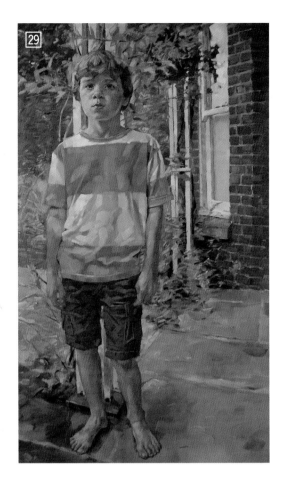

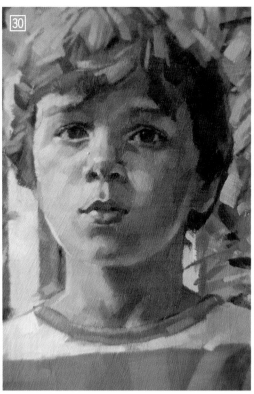

Day Four

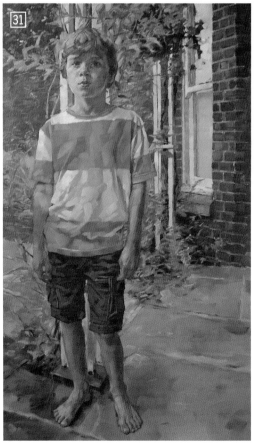

[30] As sometimes happens on returning to a painting, I am pleasantly surprised that it looks like there is not a lot more work to be done on it to make me feel that it is finished. Sometimes it goes that way and you shouldn't feel like you have to 'earn' the right to complete a work simply by putting a lot of hours into its completion… sometimes elements comes together relatively quickly and painlessly and that should be accepted with gratitude and not suspicion and unease.

At this final stage, I decided to put a very subtle glaze on the face, arms and legs. I felt that the shadows on the skin were a little cold so warmed them up with a mixture of Burnt Sienna and Ultramarine. Once applied, I manipulate it with a clean, soft brush and leave it to dry.

[31] On returning to it the following day, I realize that everything seems to be OK and it's safe to say it's done.

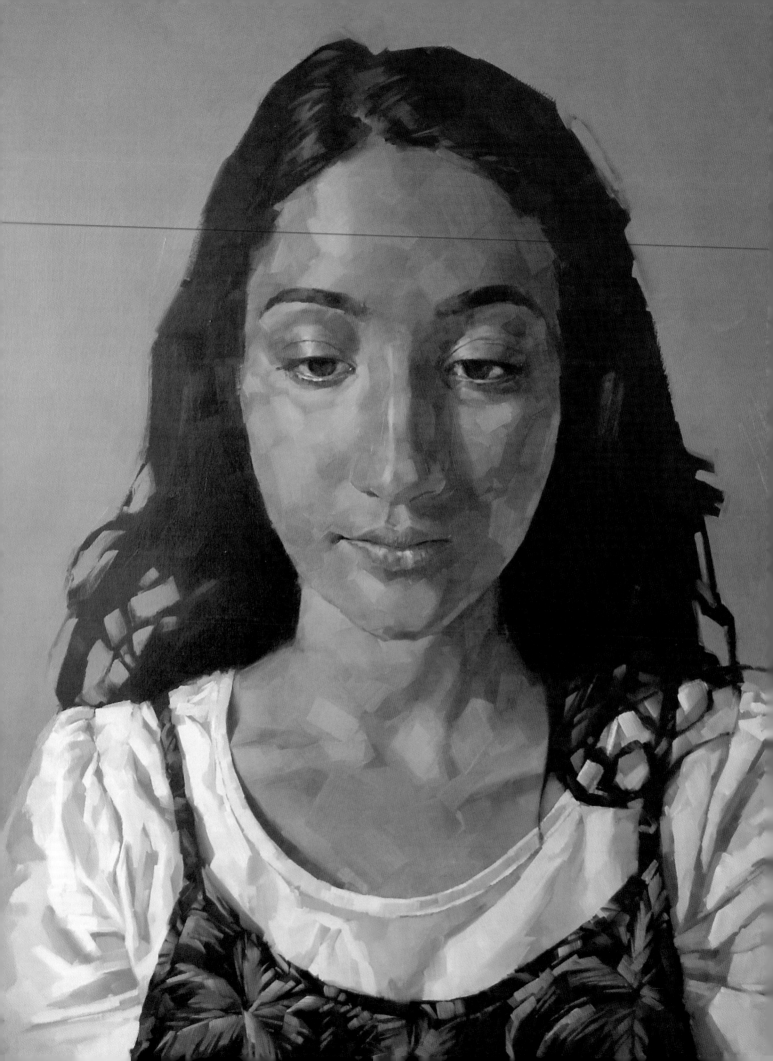

Taslima

(age fifteen)
24" × 20" Oil on Board

The demonstration pieces I have decided to do in this book are intended to show that the difference in ages of the subjects will often affect the decisions made when planning and composing the portrait.

In this case, the subject is Taslima, who is fifteen years old. At this age, a face undergoes a lot of changes and the structure often becomes more refined and defined. This often coincides with a self-awareness in the sitter that will hopefully lead to a more collaborative outcome. In basic terms, this is the stage when a juvenile is beginning the move towards adulthood and a good portrait can capture that in some way.

As with the other portraits in this book, I started with a couple of simple compositional sketches.

Bearing in mind Taslima's age, I decided to work on a very basic, clean design that had the minimum of background. This approach was used to suggest the transitional stage to which I have just alluded as, to me, this treatment has a little more gravitas, befitting a stage of life that can often be bewildering and strange. The fact that Taslima isn't meeting the viewer's gaze is intentional as this age can often be a time of great self-consciousness and uncertainty and a teenager is endeavouring to find their place and voice in their world.

As I have previously mentioned, doing little thumbnail sketches is all very well but these plans often get put on the back-burner when you are actually interacting with the subject. In this case however, there was a greater degree of understanding between myself and the subject,

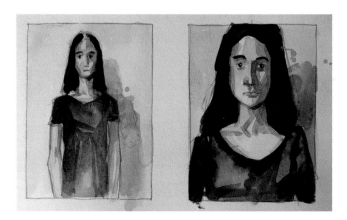

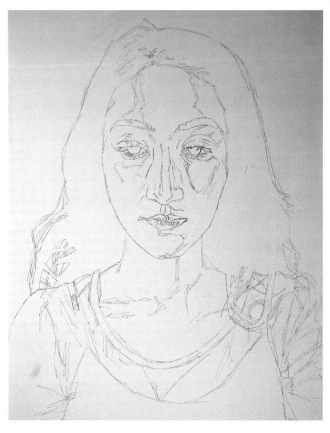

Taslima, 23" × 20" oil on board 2016. An almost symmetrical treatment of this composition as I wanted it to be a very thoughtful and transitory time in the life of the subject.

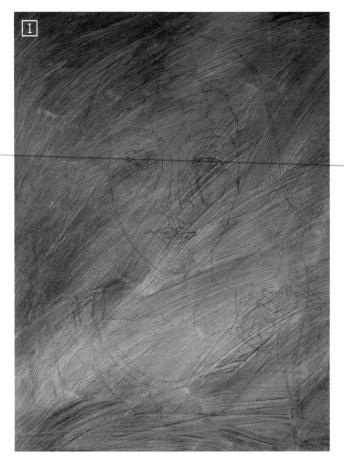

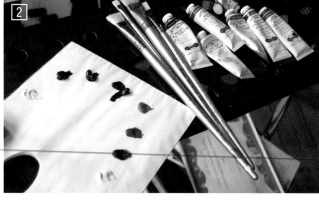

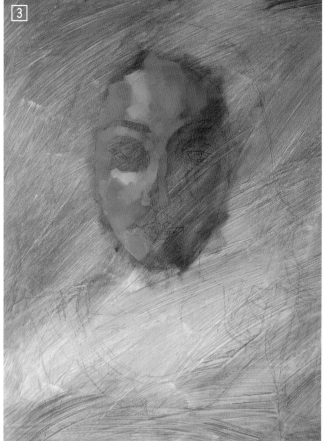

so I was able to follow relatively closely to my original thumbnail ideas.

The photographs were taken in very soft light as I wanted the composition to be tonally quite harmonious and subtle.

Generally I work from a few general images but in this case there was a specific reference that I felt would work well. I prepared a primed wooden panel as before, and drew up the basic outline onto it. The drawing stage to me is an important one and I approach it in a very specific and precise way.

Day One

[1] When beginning a painting, I find there is nothing quite as intimidating as starting with a blank, white surface. Once the outline image is complete, I will cover the image with a thin acrylic wash or *imprimatura*, thus creating a helpful mid-tone to work from.

[2] The limited colour palette I use is arranged in a semi-circle on my tear-off palette along with a dipper containing a small amount of Liquin on the side.

[3] I tend to mix the colours in a relatively intuitive way and am constantly adjusting the pigment mixtures until I have achieved more or less what I want. At this stage I am not too worried about the exactitude of the colour as there are a number of ways to adjust this at a later stage. I have never been particularly strict on my process and as I said earlier, all that matters is the end result and how I get

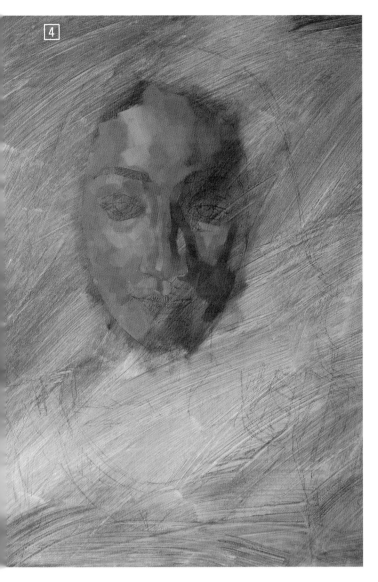

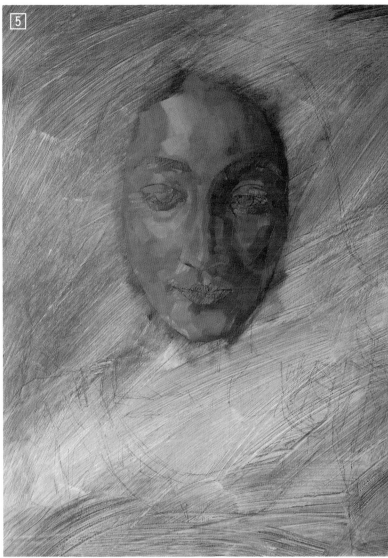

there is often surprisingly unplanned. Starting a portrait is exciting in the way that you have a definite starting point but the finishing point is less easy to predict... it might take a day or may take months. That, in a nutshell, is the joy and the pain of painting.

When mixing the paint, I add a very small amount of Liquin to smooth flow and speed the drying time a little. I really do like the glowing, silky quality that this alkyd medium gives to the paint surface but I do use it very sparingly.

The initial blocking in of the portrait is a relatively quick process. On a portrait this size (24" × 20") I use a quite a large, broad brush at this initial stage. In this case I used a 1" short flat.

Having already established a mid-tone, I chose to build up the lighter tones first as personally find it easier to get the desired tonal range.

4 It is a matter of personal preference as to where you actually start when painting a portrait. Some begin with the eyes as this is the most physically engaging feature but I generally start with the larger surfaces, for example, the forehead, cheeks and neck area.

The broadness of the brush enables these areas to be blocked in quickly and the colours used at this stage are predominantly Yellow Ochre, Burnt Umber and Cadmium Red. Titanium White is added to gradually create more dimension to the form but here again it's done very quickly so I am not too worried about accuracy at this stage.

5 Gradually I started to work into the shadows a little, using mainly Cadmium Red and Ultramarine, with perhaps a little Burnt Umber for depth.

6 All the while, I was trying to maintain the form of the underdrawing and would wipe off applied paint if I felt this form was being lost or becoming too obscured.

Once the head was at a stage that I was happy with, I started to block in the neck. It is important to be aware of how skin differs depending on where on the face it is.

7 The skin around the collar bone and throat is very delicate and must be treated appropriately as should that of the forehead. This can generally be achieved with confident and decisive brushstrokes. It's probably an obvious thing to say but it is worth remembering that skin and flesh on a head is stretched *over* a skull and the points of contact will behave very differently. In some parts the layer is thin and in others thick so tonally, these areas are very different.

Still working quite quickly, I started to add lighter tones to the existing applied wet paint and this is where some quite pleasing accidents can occur. I'm still keeping it all quite simple as when painting in stages like this (where the portrait isn't to be completed in one session), it is important to apply the paint while bearing in mind that you are painting in preparation to some degree for the next session, when the first paint layer is touch-dry. One of the main problems when painting is knowing when to stop. It is a very fine line between creating and destroying, from adding and subtracting so when you are happy with your work, it is wise to leave it and not try to improve on it. I have painted many things that I have been quite pleased with only to have ruined them through not knowing when to stop.

I have intentionally kept away from blocking in the defining characteristics of the face so it is at this stage that I begin to define eyebrows, eyes and lips.

8 Using the brush's flat point, I draw the features in with Cadmium Red and Prussian Blue. I avoid using black as I want these darker lines to still contain colour and tone but care should be taken with Prussian Blue because although it is a fantastically versatile paint, its pigment is incredibly aggressive and can often be overpowering.

Lips are blocked in and the eyes too. The 'whites' of the eyes are rarely that, so a bluish tint is used.

[9] As with the skin, it is useful to remember just what an eye is: a ball within a socket, covered by the eyelid and therefore its shape and construction need to be considered.

At this stage, I was fast approaching the end of the first day on this portrait so I began to block in the hair and cut sharply into the face, to create the form and start to actually make the elements of the portrait relate to each other a bit more.

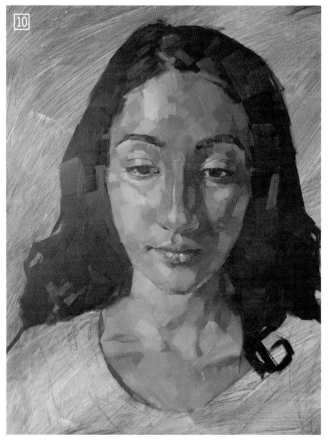

[10] As I mentioned before, this in part is done in prepa‐ ration for the next time that I work on this portrait so I will get it to a stage that I'm happy with. It is not entirely accurate either tonally or physically but these can be changed quite easily in the next stage.

I complete the blocking in of the hair making sure not to get too caught up in detail and form, as this will be done when I cut the background in around it.

At this stage I will modify the skin tone slightly and blend the hair to the forehead a little more. I often do this with darts of Prussian Blue to inject energy and harmo‐ nize between the different planes of the face.

I will now leave the paint to dry for a few days. The tones will inevitably change during this drying time but

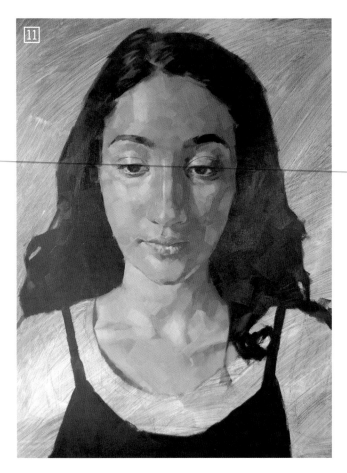

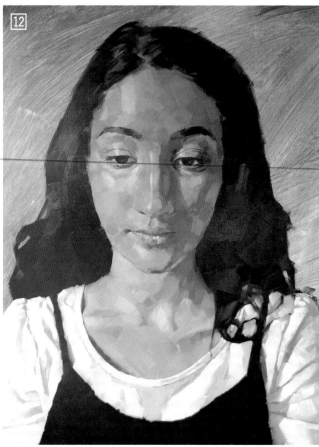

as I use a very controlled colour range, resuming working on it will not be too difficult. Leaving a portrait for a few days gives me a useful chance to think about it and work out decisions that I need to make in the next session. At any one time I am working on three or four portraits in the studio and even the basic procedure of flitting between the different works often illuminates problems that I have in them and makes finding a solution a little easier.

Day Two

11 When I came back to this painting, the paint layer had 'settled' to a degree and the surface was dry enough to proceed. Still at this stage, the likeness was not fore-most in my mind so I decided to continue blocking in the clothing and background so at the next stage I could then work on the portrait as a whole.

I began by blocking in the dress with some very dark tones at this stage. I'm very interested in the shapes created by composition so I often change the colour of clothing to best suit the balance that I'm trying to achieve.

12 I also added a few highlights to the face, in Prussian Blue mixed with Titanium White. I try to avoid highlights of pure white as I think it doesn't necessarily represent what occurs in reality to the face. There is always a lot of bounced light from the external sources (windows and so on) and reflected light (from clothes, for example) and it is important not to be too literal with the photographic source material. As suggested earlier, it is important to use the photographs as 'a tool and not a rule'.

I then began to fill in the white shirt. This is done with Titanium White, Prussian Blue, Yellow Ochre and Cadmium Red. The paint is built up with broad, flat strokes with directional application suggesting the form beneath. One of the many beauties of painting is the introduction of colours that, in isolation, could appear out of place but in the context of the portrait, add energy and light. Using pinks and blues for shadows brings a degree of life and freshness that a literal shadow would not.

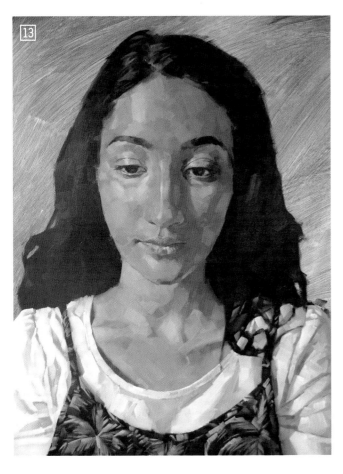

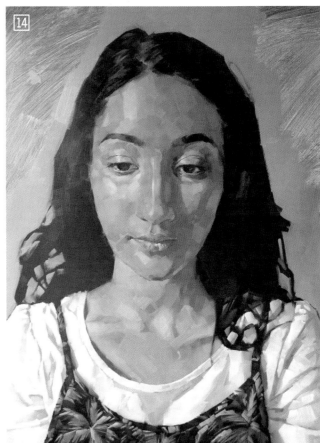

[13] I felt that the composition was a bit stark so I introduced some pattern to the dress. I did this in a quick, freehand way as I didn't want to get too hung up on the details that I felt were irrelevant to the overall painting.

[14] Now that the figure was initially painted, I mixed a suitable background colour. I wanted it to be quite neutral and fresh so using a palette knife, I mixed Prussian Blue, Yellow Ochre, Burnt Umber and Titanium White. I mixed this quite rapidly and made sure I had a sufficient amount to cover the entire background to ensure a consistant tone throughout. Once the colour was mixed to my satisfaction, I began to apply it to the board by cutting in sharply to the hair and shoulders.

[15] This is a particularly pleasing stage of painting as it quickly brings a cohesion and a substantial quality to the portrait. Once this stage was complete, I was best able to judge the progress so far. Here again, I left it to dry for a few days before returning to it afresh.

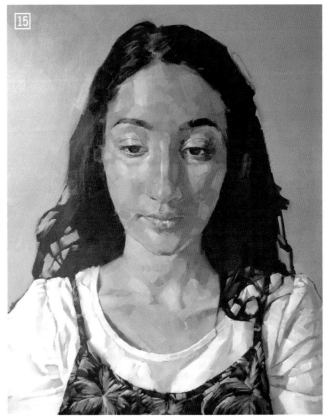

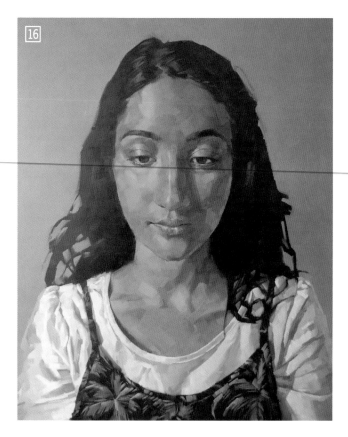

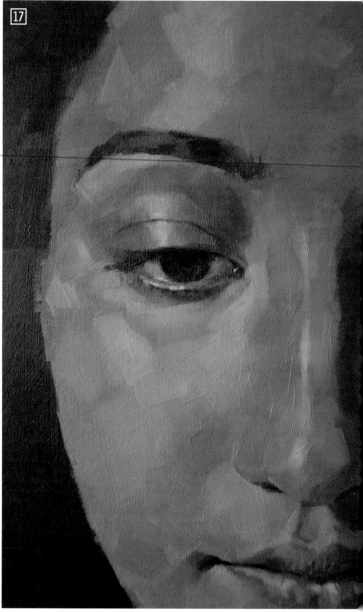

Day Three

16 When I came back to this painting after a few days, I was better able to judge what needed to be done. During this drying time, the paint colour and tones shift slightly so hopefully there will be a better cohesion with the previous layer of painting. There were a number of things that were bothering me about the way I'd painted some of Taslima's features and the few days away from working on the portrait enabled me to pinpoint exactly what they were. This is quite a common problem and it's important to realize that it is a normal part of the process and not a sign of failure. There is a limit to what you can and can't do in a session of painting without having a detrimental effect on your progress so far. The eyes are a focus of this composition and they were a little vague so I spent a bit of time rectifying this.

17 I also worked a bit more into the white of the shirt to give it form and crispness. The square-brush technique I use is particularly effective for this as the various information of folds and creases can be recreated by varying the direction of the brushstrokes.

To me, the beauty of painting in oils is the complexity of the paint surface that can be built up to create a coherent image. This close-up of that surface shows how I have introduced Prussian Blue to the skin tone, which adds a delicacy to it. In reality, hints of these colours are there but not in these solid slabs that I have applied. It's the visual mixing that harmonizes the overall effect.

At this stage, I also applied a thin glaze of Burnt Umber and Prussian Blue to the eyelid area to create greater depth and warmth.

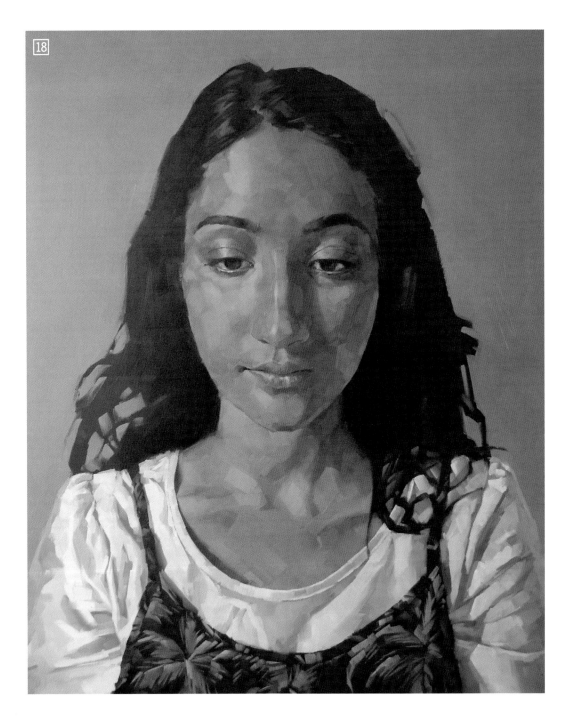

Applying a glaze

A glaze is a thin, transparent layer of paint that is applied over a layer of dried paint to manipulate the overall optical effect. This is particularly useful with skin tones and enables you to change the portrait tonally yet maintain the details in the previous layer. As with the rest of the painting, I use Liquin as the glaze medium so that the drying times will be similar.

18 At this point I feel the portrait is completed because if I were to continue, I think any energy and freshness that I have created would be compromised by overworking.

It's always a surprise as to when a painting gets to a point where I feel it is done. Sometimes it happens earlier than expected and that is why constant reassessment is important during the creative process of a portrait.

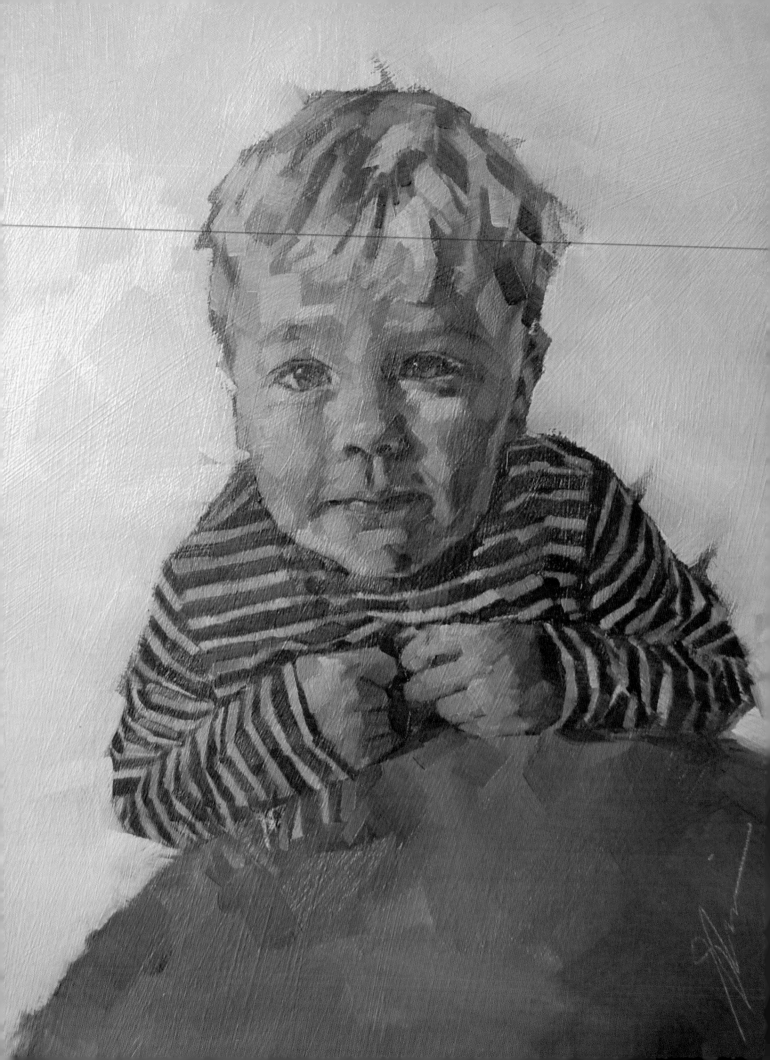

Luke and Arlo

This chapter features two small portraits, each completed in one session, and it will hopefully convey the excitement and enjoyment that working in this way can give you. I have always liked to work pretty quickly. I think this maybe is something that I have learnt from my other career as an illustrator, where tight deadlines are an occupational hazard. However, I find in my painting, having as long as it takes to complete the work is often, in itself, self-defeating as it encourages me to get held up with minutiae and endlessly tinker with details. This of course works for a lot of painters and the painting process is the most personal of things but I do get bored easily and as a result, seem unable to paint slowly.

This caused me a lot of worry initially. Should I paint like this? Should I paint like that? This artist paints like this, that artist paints like that, and so on... Looking to others for advice and technique is of course essential but it is also important to develop your own working style and whatever you settle on and are happy with, is the right way for you. At the risk of labouring the point, there really is no wrong or right way to paint... just *your* way.

Luke (age two)
Monotone study
10" × 8" Oil on Board

[1] The first example in this chapter is a quick monotone study that was completed in one session. It's sometimes a very useful tonal exercise to paint this way, be it for a preliminary work to familiarize yourself with the subject or a finished and energetic study.

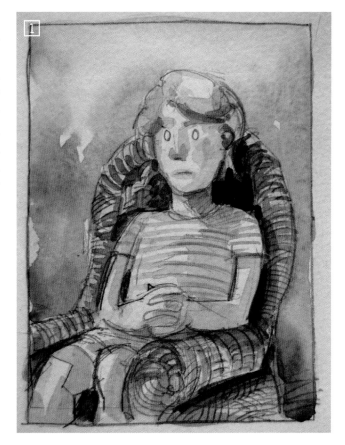

Luke, 10" × 8" oil on board 2016. This monotone portrait was completed in one session, which hopefully helped in some way to convey the freshness and vitality of the subject.

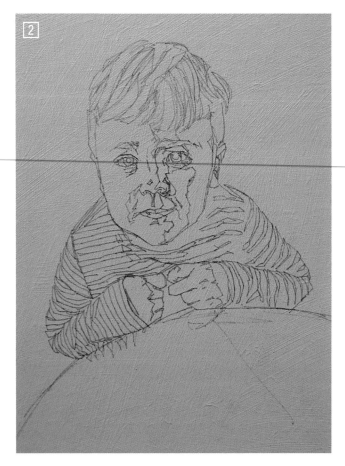

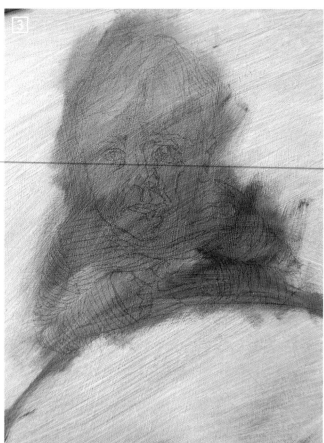

I began with the usual sketch but as Luke is only two years old, I was aware that there may be some difficulty with his attention span so was keen to fix him within a relatively controllable environment.

2 As you can see, the initial idea was to have Luke in a chair but as so often happens, the reality of the day changes that completely. Luke is a lovely little chap and like most children of his age, is into everything. In the room where I was to take the reference photographs, there was one of those large therapy balls. This was immediately commandeered and proved to be a really good compositional solution. The idea of using the chair was now a distant memory.

After I had taken the reference that I felt I needed, I went back to the studio and drew out the image onto a small wooden panel.

3 I wanted the curve of the ball to have quite a presence within the composition as I felt that graphically it made an interesting and unusual shape.

I really wanted to paint this small portrait in one session (about five hours) and also with a very restricted 'earthy' palette. Along with Titanium White, this consisted of Raw Umber, Burnt Umber, Yellow Ochre, Burnt Sienna and a little Prussian Blue too.

The step-by-step photographs shown here are intentionally taken with a strong raking light to illustrate brushstroke direction and the general texture.

A light Burnt Umber acrylic *imprimatura* is applied and once that was dry, I applied a little Burnt Umber base oil colour.

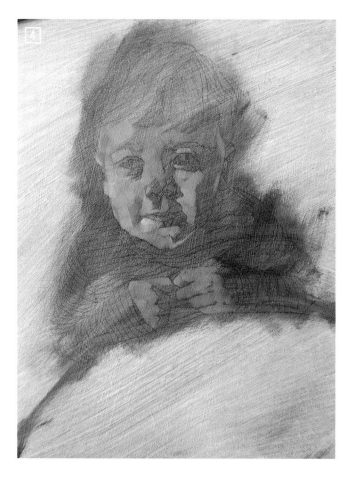

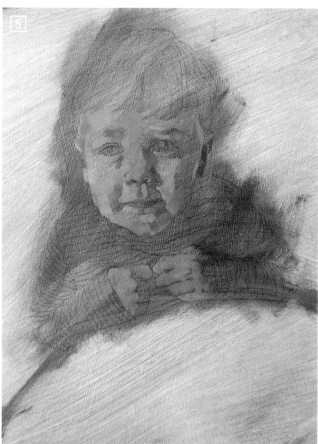

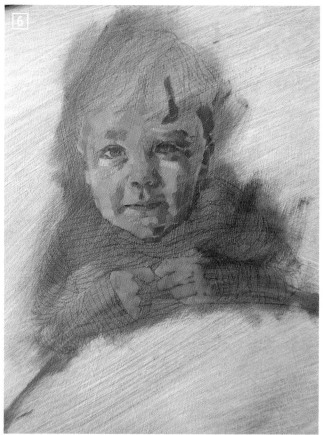

[4] I find that this often helps when applying the paint-ing, giving it a degree of unity and cohesion.

When I start all my portraits, there is always a des-perate urgency to 'find' my way into the painting. In this case, I started to block in the lighter tones, where the light falls on Luke's face and hands.

[5] Even at this stage, and because of the speed at which I was working, I tried to add shadow as I went. As this piece is quite small, I was very keen to follow the drawing beneath and not stray too far away from it. Despite the small size, I still wanted to use relatively large brushes but as a result I was continually obscuring the lines beneath. When this happened, I simply wiped off the paint with an earbud and re-worked it.

[6] I started to add heavier shadows that began to suggest the form of the face and continued to do this until I felt in the position to work into the eyes and lips.

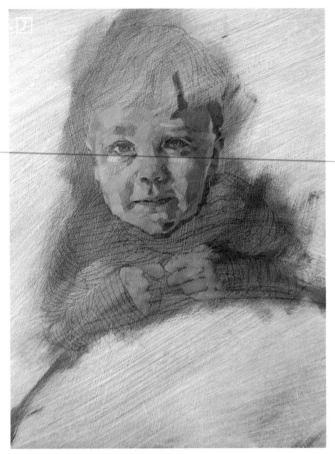

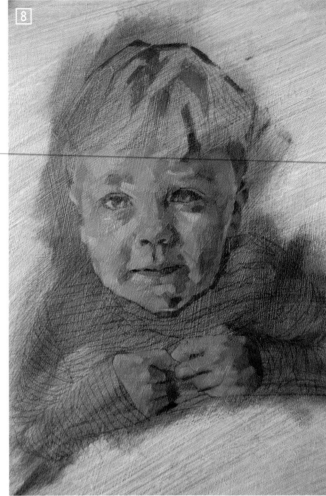

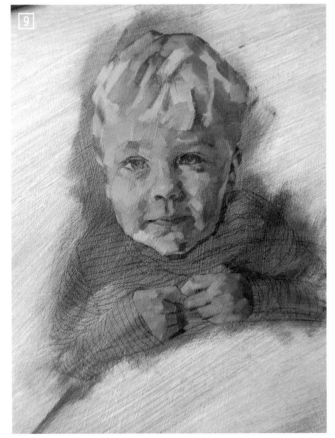

7 There were many times within these early stages that I felt that I was losing control of the portrait. This could mean that I was losing the likeness or just applying the paint in an over-fussy and clumsy way. If this got too bad, using a fine brush, I applied a very precise outline in Umber that helped me to maintain the likeness and free up my painting strokes.

Shadows were applied to the side of the face and also to the hands and hair.

8 The jaw line has been picked out too to give the face its shape and very quickly, Luke's features started to become recognizable.

9 I then blocked the hair in and tried to pick out some highlights in it as I went. A little bit of Prussian Blue was added at this time to give the hair a slightly different tone to that of the skin.

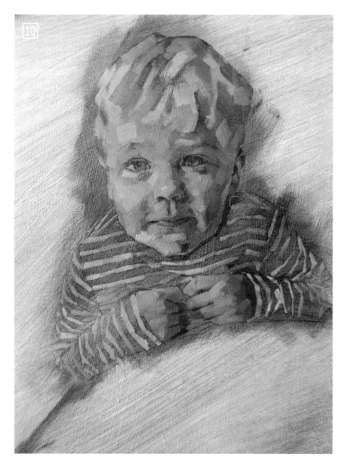

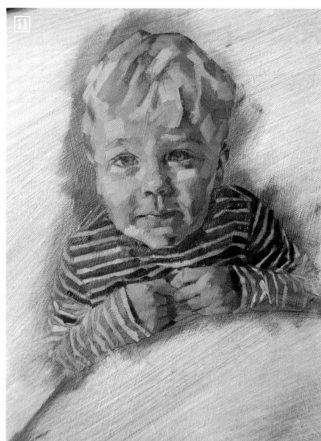

10 Luke was wearing a striped top so at this point I decided to quickly block in the light stripes using a fairly broad brush.

11 This helped me to give a degree of volume to the body and when the dark stripes were added, there was a sense that the form was taking shape.

12 Here I added a few flashes of Prussian Blue to add a little vibrancy and looseness.

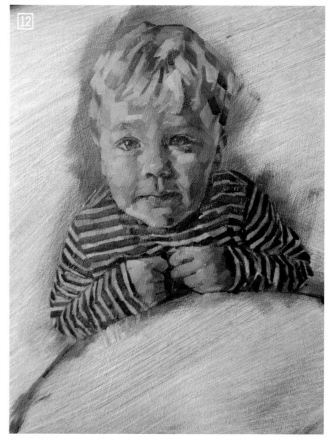

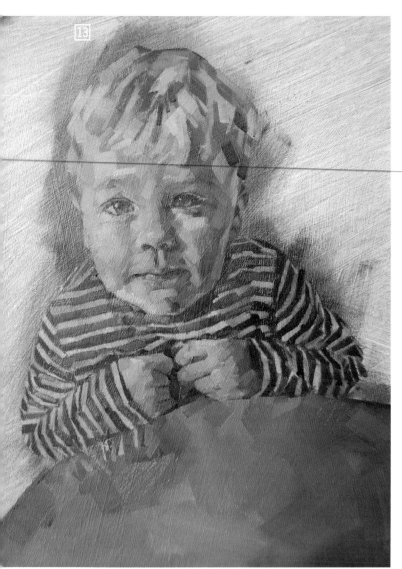

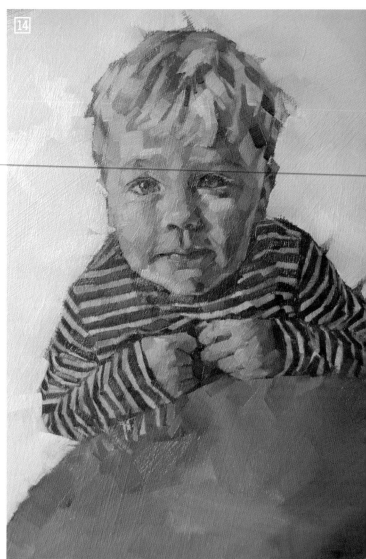

13 I can't really explain why this does add a little something to the painting but it does seem to bring a little animation to the composition. I also added the little catch lights in the eyes. This is usually something that is done at the very last stage of a portrait, as it's an encouraging 'ping' that brings the subject to life but sometimes I simply can't resist it and put them in earlier.

Next I moved onto the ball. This was potentially rather a dominant form within the composition so I was keen to treat it quite loosely. I blocked it in fairly quickly, leaving a lot of the acrylic under layer showing through. The roundness was subtly suggested by adding lighter tones and the reflections of the sleeves and hands.

14 Now that the figure was mostly complete, I undertook the very satisfying part of painting the background. I really enjoy this part of the painting process as it really brings the whole thing together. I used Titanium White mixed with Burnt Umber, Yellow Ochre and Prussian Blue for this and a larger brush than I have done in the rest of the painting. Paint was applied from the figure outwards, almost like it is radiating from it and because I was working fast, often parts of the *imprimatura* were left exposed. I didn't particularly mind this as it just added to the energy that I wanted to try and keep.

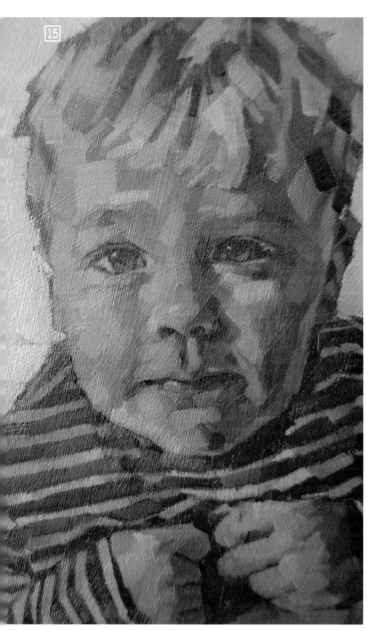

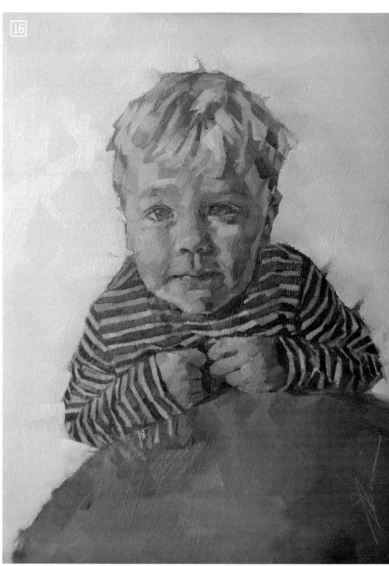

15 In this close up, you can see the importance of the directional application of the paint.

16 The under layer of acrylic colour remained showing through in some areas and pleasingly resulted in a kind of halo effect. This appeared more through luck than judgement because as I was using a larger brush on a relatively small and precise composition, my ability to be completely accurate was less than I would hoped for.

At this stage I feel the painting was done.

The key to this portrait for me was to keep it uncomplicated and give it an immediacy. I wanted it to be charming and reflect the subject's playfulness and simplicity. Sometimes, painting in a monochrome manner is very rewarding and testing yourself to find solutions that don't rely on colour is a really worthwhile and satisfying exercise.

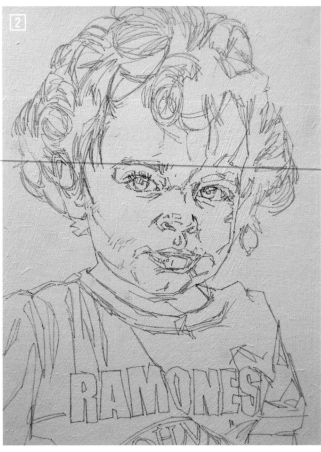

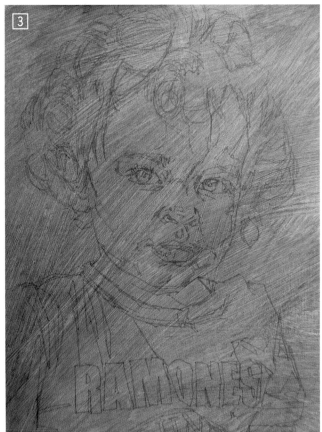

ARLO (age two)
Colour Study
Oil on Board 10" × 8"

[1] This second portrait example is of another two-year-old, Arlo. I wanted to do this as a colour study which means that I would approach it in a different way to the previous portrait in this chapter.

As always, I began with a little sketch but from the outset I really wanted to keep this composition quite simple and just concentrate on a study of the face.

[2] I spent a while taking the photos as I wanted to give myself some options as to the position of the head. I settled on a three-quarter view as I think it seemed the most suitable way to convey Arlo's playful character and it also got to show off his proudly worn T-shirt.

Like the previous example, I was painting on a relatively small wooden panel so the head was to fill a large percentage of it.

[3] I transferred the image to the panel and then applied the acrylic wash as before.

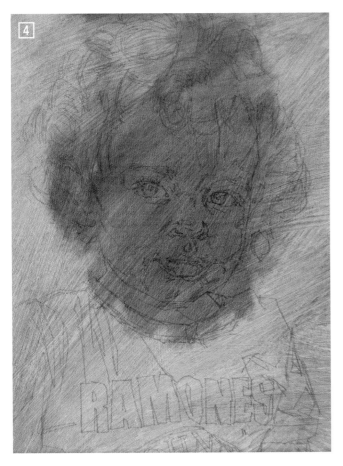

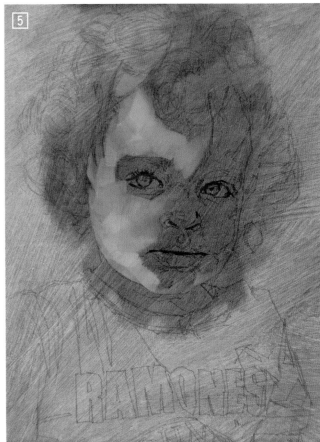

[4] Time, I felt, was of the essence so I laid out my palette of French Ultramarine, Yellow Ochre, Cadmium Red, Titanium White, Burnt Umber, Burnt Sienna and Prussian Blue. Again working on the base of the thin Burnt Sienna wash I began to paint in the areas where the light fell onto Arlo's face.

[5] The colour mix I was using here was the blue, ochre, red and the white. It's applied with a broad brush, in decisive, directional strokes and in case I lost the under-lying drawing in the chaos of paint, I quickly outlined the eyes and key geographical points in a mix of red and ultramarine so I didn't lose where I was.

[6] I continued to block in the face, adding a degree of shadow around the cheeks and chin.

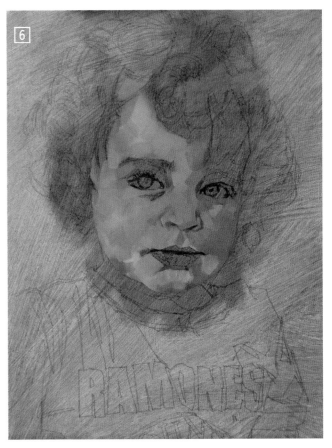

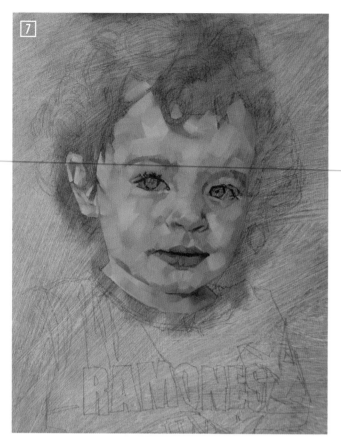

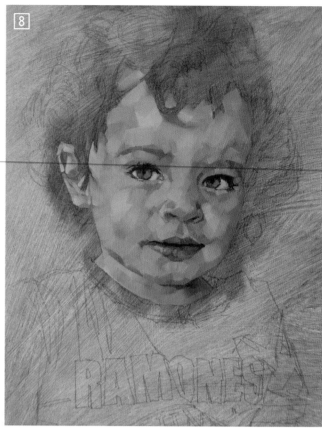

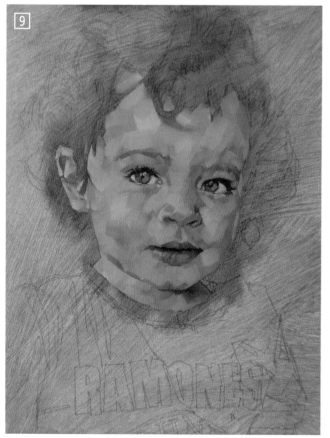

[6] This was pretty imprecise but at this stage I was not that worried about it as I just wanted to get the first pass done so I could see where I was. The shape of the face was developing quickly as I was trying to add the dimensional moulding aspects as I went. A little shadow was added around the neck to push the chin forward and the lips and ear were quickly suggested.

[8] One of the many enjoyable aspects of working like this is that the piece starts to come together in a kind of chaotic rush. Once the eyes were roughly sketched in, the portrait suddenly came to life and that panic that gripped when I couldn't decide whether this portrait was a disaster or not gradually subsided.

[9] I added flashes of Prussian Blue and Titanium White to the flesh tones which optically added a sort of translucent quality. In reality, these colours are all present in the make-up of skin-tone so you can be surprisingly unsubtle when introducing them with paint. These adjacent colours mix optically, giving a convincing 'feeling' of skin tone that on closer inspection, can appear a little insensitive and a little abstract.

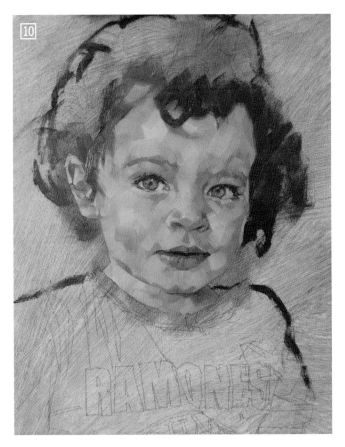

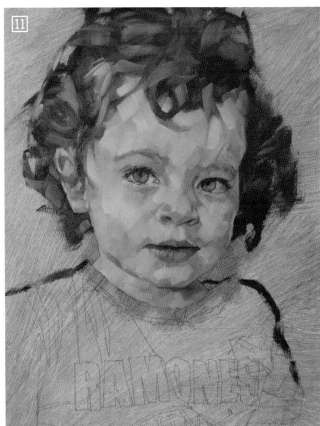

10 I was relatively happy with the flesh tones so then moved onto the hair. Using Burnt Umber, Burnt Sienna and Prussian Blue, I quickly sketched in the outline of the hair and applied the darker colour to the areas that immediately came into contact with the previously applied paint. I tried to be literal with the painting of the hair and copy the actual direction that it followed. The square brush is particularly good for this, as a sweep or a curl can be suggested very fluidly and convincingly in a single stroke.

11 Some highlights were added to the hair using the ochre and the white and some of the skin tones are lightened. I felt on reflection that at this stage there was a little too much texture to the face so went about smoothing out some of the harsher brushstrokes. After all, Arlo is only two and the skin at that age is pale and delicate and the brushwork should ideally reflect that.

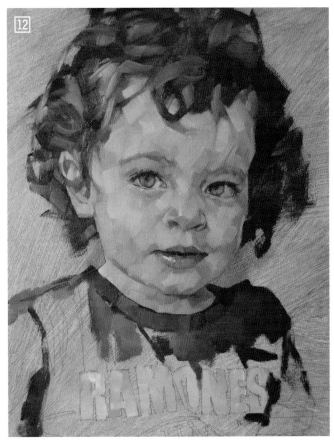

12 Also, I worked back into the eyes a bit more and took out the catch light as it was too distracting at this stage.
 Next I started on the T-shirt.

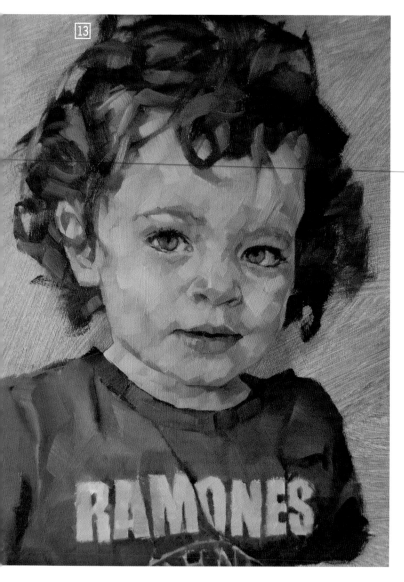

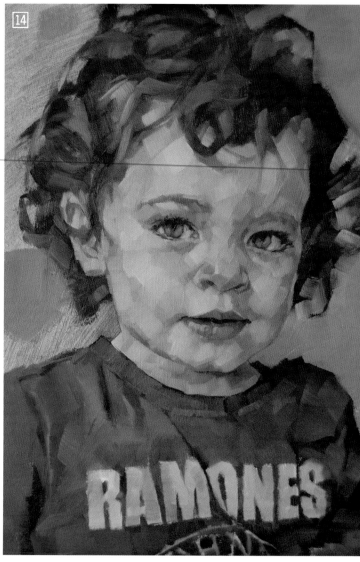

13 In reality the shirt was a faded black colour so I mixed Prussian Blue with Cadmium Red, Burnt Umber and Titanium White to get an approximation of this. Colour mixing to me has always been a process of trial and error. I know a lot of painters pre-prepare the tones they are to use prior to painting but I prefer to mix as I go on the palette. This process isn't very scientific but hopefully I get there in the end and I enjoy the constant adjusting of the hues until I have what I feel is right. The T-shirt lettering is sketched in with a degree of accuracy but the underlying layer of *imprimatura* again enables me to not get too fussy and worry about precision.

I carried on down this path of blocking in the shirt and carefully picked round the lettering with the darker paint and tried to suggest the folds of the shirt by the direction of the brushstrokes.

14 I wanted this portrait to have a quite a similar tonal value throughout so when it came to the background, I didn't veer too far away from some of the tones found in the T-shirt. After adding a few little bits of heightened colour in the shirt, I began to steadily cut in around the figure with a mix of the Burnt Umber, Prussian Blue and the Titanium White. This, as always, is the incredibly gratifying part of the portrait as it allows me to tie up together the two elements, figure and background and give the portrait a greater degree of unity.

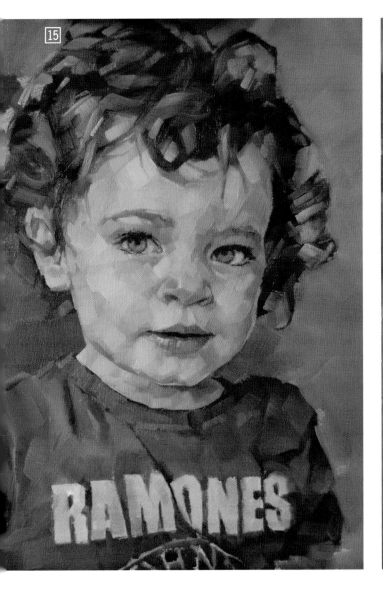

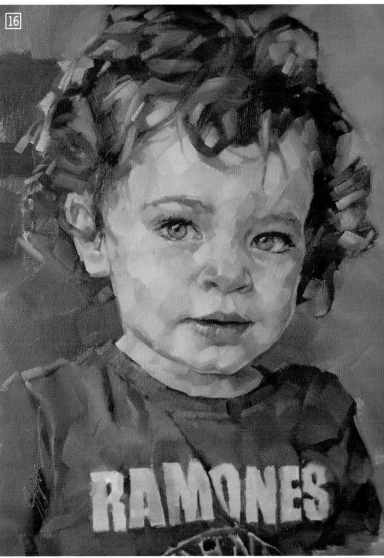

15 When cutting in this background, I started the brush-stroke at the edge of the figure and worked out from that as this gave me a really nice sharp edge that really pushes the figure away from the background.

16 As most of the painting surface was covered, I then considered that most of the foundations were there so I could then just go back through what I'd done and have a bit of a tidy up. At this stage I could best judge what wasn't working within the paint layer and in this case, I lightened some of the shadows again as I felt that they were ageing the subject too much. This was a relatively subtle adjustment but it made a significant difference to the overall feel of the portrait.

The final addition was the catch lights in the eyes. Unlike the other portrait in this chapter, putting these in at the very end seemed the right thing to do and just put the finishing touch of life into the image.

These catch lights were a mix of Prussian Blue and Titanium White – I was trying to avoid using pure white as it often can look a little synthetic and unnatural. Looking at the final image, I thought that overall it was a good likeness and contained the degree of energy that only painting in one session can give.

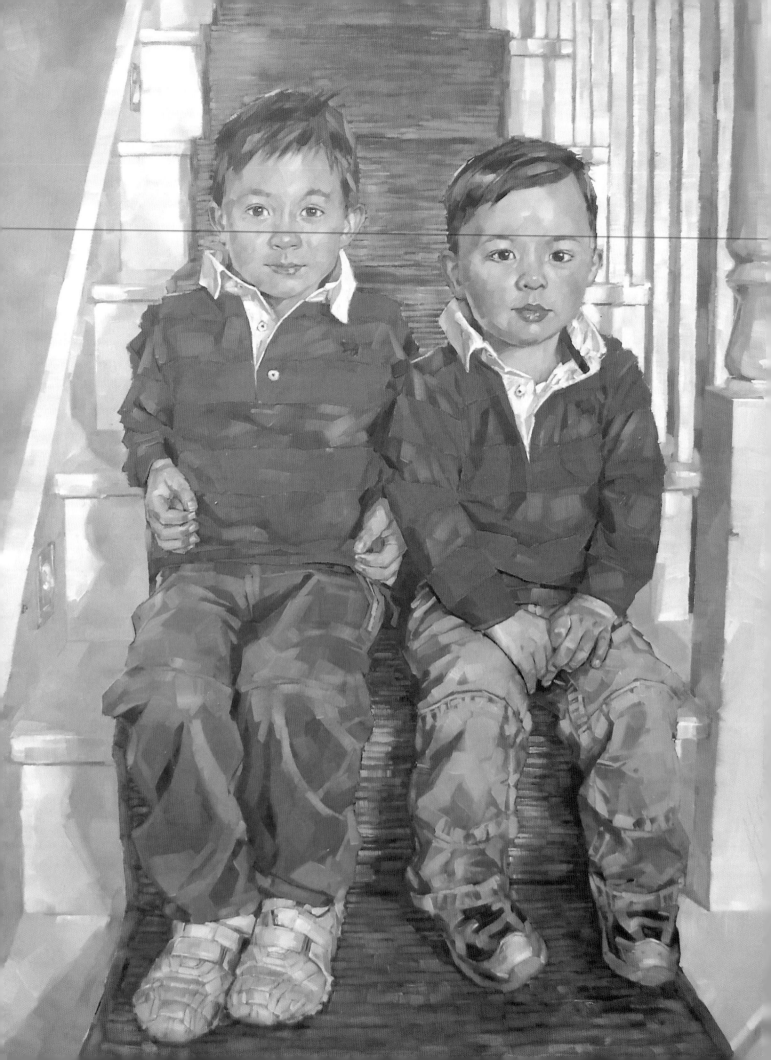

Other Works

In this chapter, I outline some other examples of my portraiture that have, in their own way, posed particular technical and compositional challenges and I explain the solutions I found for making them work.

Tom, Ben and Joe

[1] In the first example I was commissioned to paint three brothers whose ages ranged from about six to thirteen.

[2] After a meeting with them and their parents, we settled on the idea of a triptych. This was a particularly interesting prospect to me as it raised a few logistical problems that would require a good deal of thought to solve.

The idea for choosing to do a triptych was that each subject would have his own portrait and when the pictures were hung together, there would be a thread of continuity running through them. It was equally as important for each picture to exist independently as a portrait as it was for them to hang together, so a background solution was necessary that would fulfill both these criteria.

I did a small thumbnail rough in an effort to see if perhaps a tree could be used as a binding presence in the piece.

Edoardo and Lorenzo, 24" × 20" oil on board 2013. A background that will remain a constant is very useful when painting multiple figures. In this case, using the staircase enabled me to take individual photographs of the brothers and later, back in my studio, assemble them into a composition where they were in correct proportion to each other.

I initially thought that maybe this was a little too much of an obvious and straightforward device to indicate family and lineage but in this case I felt it would be particularly apt as all three boys were very active and loved to play outdoors. There was also a shared love of sports so we all liked the idea of introducing some sporting elements to a couple of the portraits too, namely cricket and rugby.

As you can see, the finished work is quite similar to the rough but the disparity in the sizes of the brothers forced me to rethink having all three boys standing in the initial composition as that would have made the youngest's portrait look very incongruous with the other two.

When it came to taking the photographs, we went to a park that was nearby to the family home and I searched for a suitable tree for the background. I didn't really have much of an idea as to how to solve the size problem and was putting my faith in the park's trees and geography hopefully offering a solution. I pretty quickly found a tree with a horizontal branch that when sat upon by the youngest boy, evened up the height disparity and also offered up an interesting compositional shape. I spent quite a while taking photographs and as the tree provided a constant size reference, I was able to photograph the boys individually which gave me a little bit more control over the whole process. It was a beautifully sunny day and the dappled light on the tree also provided another descriptive aspect to the piece.

Back in the studio, I decided on each portrait being 16" × 24" and I drew up and painted these portraits all together on the large studio easel. This enabled me to keep a coherence to the three portraits and a consistency with both the colour and the balance of the composition. This

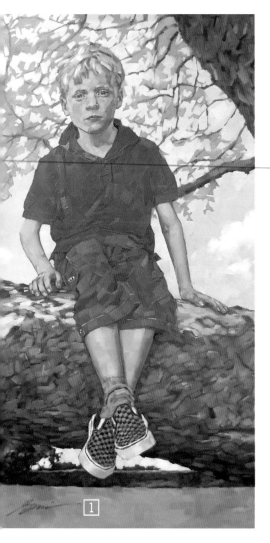

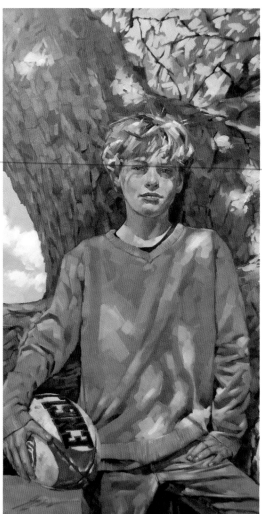

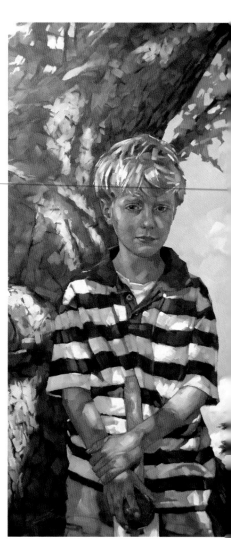

Lorenzo and Edoardo

[3] This double portrait of Lorenzo and Edoardo was in principle going to be a very straightforward process. Like most things that are in theory simple, it very rarely turns out to be that way.

I visited the family before starting work on the commission and this proved very useful as it was really helpful to be able to meet the subjects of the portraits and try and formulate a plan. Both of the boys were absolutely great: bright, interested and excitable... everything children should be. But therein lay my problem. Logistically, to take photos of them both together at the same time was always going to prove tricky. This is absolutely no criticism of them as they were just being delightful and excitable sitters but while that's all great fun for them, it didn't really help when I was trying to take reference photos for a portrait.

was a particularly enjoyable set of portraits to do as, not only was it a great family to spend time with but it was also a truly collaborative project, the result of which both myself and the clients were really pleased with.

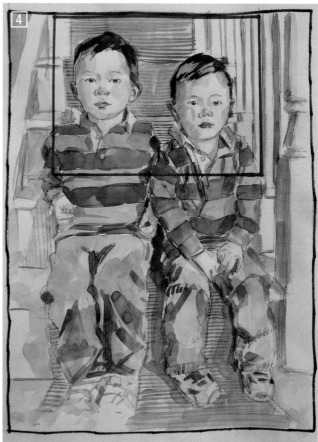

I had a quick look round their house to find a suitable background for the portrait and decided that the stairs would be perfect for two very good reasons.

In childhood, stairs have a very significant role. They are often the scene of reluctant retreat (such as going up to bed) or that of unbridled excitement (for example the start of a day's play or Christmas morning) so I thought they would be a very apt and symbolic setting for the painting.

After a brief time photographing the brothers on the stairs together, it very soon became apparent that I would have to photograph them separately as they were laughing and distracting each other to such an extent that I wasn't able to get what I needed.

I had a basic idea of the layout for the portrait and using the stairs enabled me to have a consistent element with which I could ensure that the differing sizes of the brothers were easily transposed.

4 With a double portrait it is very important that the figures be the correct size in relation to each other. I have used this 'constant background' idea a number of times, as quite rightly, children have much more important things to be doing than sitting for a portrait and it is highly desirable to get the reference you need as quickly and as painlessly (for all concerned) as possible.

You may also notice on the rough sketch that there is a red square drawn on it. This was an early idea that I had to crop the painting but I very quickly decided that a full-length portrait would be by far the better solution for the piece.

The stairs also provided a pleasing compositional construction of verticals and horizontals. The horizontals of the steps with the hoops on the shirts and the verticals of the balusters with the upright position of the seated boys.

This was a rewarding commission to do as I had to think practically as well as artistically. I needed the portrait to work and the subjects to be relaxed so had to find a way of doing this that didn't seem too laboured and contrived.

Back in the studio, I was able to work from a number of references and blend them in to the single composition. This was quite a complicated portrait to do as there were a lot of elements to it but with a little bit of planning, I felt I created a portrait that captured the playful and enthusiastic personalities of the two brothers.

Andrew James & Simon Davis

A Conversation about Painting Portraits of Children

Part One

AJ As a first question, are there any particular things that you actively wish to exclude or avoid when undertaking a portrait of a child?

SD I think the most important thing to me with painting, regardless of whether it's an adult, child or anything else, is to avoid sentimentality, if at all possible. I mean during the golden age of children's portraiture, the time of Sargent, etc., some of those portraits do veer towards the sentimental and I don't particularly find that engaging and never have done really. So I try to paint quite literally and therefore show the child at a moment in its time rather than build any kind of narrative that I probably don't desire to have in there.

AJ I'll just take that point on because I think the thing you obviously stress very strongly there is an avoidance of sentimentality. Now that is obviously a broad term which can be applied in all sorts of ways, so is it the sense that it is an exaggeration or in fact a lie about the nature of how YOU perceive children?

SD Yes, I think introducing the kind of sentimentality that I don't like is bringing an adult's view on childhood... that it's a golden time. Whereas for a child it's just the time they're living and they have no comparison to any other time in their lives so I think...

AJ ... It's an outsider's projection rather than theirs?

SD Yes. Like if you have a picture of a child looking at a butterfly or something like that. That is a purely constructed circumstance, just to make it look 'isn't it all lovely, isn't it all full of wonder, when you're a child?' Which of course it can be, but I don't need to shoehorn something as obvious as that in to make that point.

AJ So my first thought is that it must have proper content.

SD My attitude towards painting children as opposed to adults or anything else like that, is that I tend to go for a simple treatment with a simple composition. Purely because, by its very nature, it will hopefully reflect the simplicity of being a child with that lack of life's complication. By its very nature, the older you get the more your life gets filled with stuff and at this stage a child is relatively uncomplicated. Obviously individual circumstances are different but that's generally what I want to project really.

AJ We'll just take that point a little bit further because here again we've got a particular reference point that you make strong acknowledgement of, which is simplicity. Again a broad term which could mean several different things and I'm thinking are we looking at the notion of simplicity as in absence or maybe simplicity as in purity – or how could you define that a bit further?

Simon Davis in conversation with fellow artist Andrew James.

SD I generally lean towards simplicity as in the treatment of the child... to be simplistic about using a plain background, or no environment at all. An environment or background to that painting in itself can often be quite a contrived thing.

AJ What, as if it's unfair to attach them to something?

SD Yes, because at that age they're not attached to anything apart from their parents and toys. Certainly when I was a child I was quite internal in my thought processes although I did have a very idyllic, exterior childhood in the Warwickshire countryside. Most of the thoughts and interests I had were very internal in my imagination. I often find that a portrait is most successful if it's kept very simple and insular, without any superfluous distractions in the picture.

AJ There's, in a sense, a taking of the viewer exclusively into a slightly more internalized experience.

SD Yes, I think so. Because adding backgrounds does suggest other things to the viewer that perhaps are not entirely necessary.

AJ Are there sometimes external influences on these decisions?

SD This varies because sometimes, particularly with commissions, there's usually always a degree of compromise. You want to do a painting that you're happy with but, on the other hand, you also have a client and you want them to be pleased with the result. So occasionally you may get something like 'can you paint the child in the garden?' and I can see why that would be quite nice but that is the third party's influence rather than what I'd maybe do.

AJ Well that's great, because I think the background and the concerns of the background is something that a lot of people are very preoccupied by. We'll return to that one again.
 So Simon, tell me the first portrait commission of a child that you ever received. When and who and your general response to it?

SD I think the first was when I was just starting painting or portrait painting to be more specific, I painted friends' kids...

AJ As commissions?

SD Not all were commissions, as some were gifts.

AJ Tell me about a memorable early commissioned portrait.

SD One of my early commissioned portraits was through the Royal Society of Portrait Painters (RP) and it was of three kids. This must have been about six or so years ago I think. There were three boys, varying ages and the client was quite specific with wanting them to be separate portraits but to have a collective continuity. That was quite an interesting problem from the start to try and find a way of tying those all up together. I settled on the triptych being bound by a tree, which is perhaps an obvious vehicle for that but I think it seemed to work quite well and each portrait worked OK on its own.

AJ So I sense we're looking at the use of background as a formal device rather than a descriptive means because you wanted to link three images and needed to link them?

SD Yes.

AJ It didn't carry meaning in, and of itself or of each individual that was portrayed in it?

SD No. The tree that I ended up using was the tree in the park that was local to where the family lived. The tree was of no direct significance to those children. It was purely a vehicle to bind it all together.

AJ So as a concession, it was a formal device. Now do you think, in all honesty, it enhanced the description of the boys or did it in any way undermine it? Having already stated your preference for simplicity and an absence of location sometimes being key. Did that compromise the work at all? Do you think, in hindsight or at the time that it was an improvement? Or just a success?

SD I look on it as quite a successful way of solving the problem of getting a coherent image that works individually and as a whole. When I look at each of the images they do work individually. You don't feel that there's something missing from one side or the other side. I think they hang together quite well. It was a particular set of circumstances and working with the client that made me choose that solution and I think they generally work pretty well.

AJ I'm looking at the arrangement of the forms and see that the tree would reconfigure if they're placed in a certain sequence. So that there's almost a prescribed hanging outcome as well.

SD Yes. Initially, the picture was to hang in the parents' home as a triptych. As the kids got older, if they wanted to, they could take an individual painting and it could be hung on its own in a perfectly coherent manner and not appear odd.

AJ It's a really good device in its original construction to actually be as prescriptive and as determined to impose that stylistic usage for a sort of harmonization or a linking.

SD Yes. I was slightly concerned to start off with. That the family tree kind of solution was a bit of an obvious one, but I don't think it was too detrimental to the whole thing. Certainly I didn't feel like I'd turned out something very literal or obvious.

AJ In the sense that the tree could only service the primary purpose because it's organic, it's not about genealogy to start with but of course that link is made as a secondary one.

Is there a particular image of a child that you could say you revere or see as a great reference point for child portraiture?

SD I'm quite attracted to the painting of the late nineteenth-century rural painters like George Clausen, Henry Le Thangue, Stanhope Forbes and some of the other Newlyn Painters. They painted portraits of children working in the fields and were refreshingly honest in their depictions.

AJ Is there a particular image that you could say embodies or engenders a response that makes it almost the pre-eminent child portrait? One that comes to mind ahead of all others?

SD The portrait that springs to mind instantly is *A Hind's Daughter* by Sir James Guthrie, which is in The Scottish National and I clearly remember seeing it for the first time. I'm very interested in the painting of that time, the rural movement that Guthrie and George Clausen and Henry Le Thangue were exponents of. I particularly like this portrait because it's very unsentimental. It's a child cutting cabbages on a farm and her job was to work. Whether or not Guthrie was commenting on the fact that for a child at that age, working was incongruous, I like its rawness, its heaviness. With the girl holding the knife, which is also counter intuitive.

AJ I think this is really interesting because there is an identifiable preference for the rural or pastoral of an unromanticized, unsentimental fashion. Now if we were to take this image and close in on the face, thereby excluding the wider context, do you think that that portrait would suddenly become a diminished portrait or is it entirely dependent on its wider context to be a successful portrait?

SD Yes, I think you're absolutely right. It is contextualized within the child's family role and a great example of the movement that these painters were involved in. A conscious rejection of the Victorian sentimentalizing of childhood, where children were all cherubs and played with kittens. By its very nature, most portraits of children at that time were commissioned by wealthy clients so subjects of a rural or industrial nature were often overlooked.

AJ So in a sense it is a portrait of an individual but it's almost a little more, a depiction of a type, of a social commentary which takes it into a broader commentary?

SD Yes, that's certainly my interpretation of it. Perhaps it's not a portrait of an individual child but more of a representation of the childhood that a certain sector of the population had at that time.

AJ Does the fact that there is a loss of the specific individual, subsumed into the wider context, matter? Is it possibly because there isn't an identifiable, unique quality to depict?

SD I think the reason why I'm drawn to this picture, apart from the fact that it's brilliantly painted and it's brilliantly constructed, is its lack of beautifying the subject, it's very raw.

AJ There's no idealization of a conventional kind but there is still the sense that the subject, predominantly the child in that picture is the recipient of a context rather than it being a description of her.

SD I think that's right. The artist has brought an agenda to that painting that the girl is unaware of. Perhaps in that sense that is what separates it from a portrait really.

AJ So it's almost questioning the notion of what a conventional portrait might set out to do, which is to depict the individual. In this case we have an individual who finds herself in a context rather than being the individual in say subsumed into a more generic context.

SD I think my attraction to this picture is probably its lack of sentiment which gives it an honesty. I'm not sure whether or not that's what the painter intended but I'm very attracted to that literal recording of the child's existence.

AJ If you weren't commissioned to paint portraits of children, would you do so?

SD The way I select people to paint is generally through people I come into contact with. For instance, not having children myself, I don't particularly come into contact with children other than when I'm commissioned to paint them. Therefore, I probably wouldn't though that's not necessarily a conscious decision but more out of circumstances. I've painted my sister's daughter a few times, all non-commissioned and that's been quite an interesting project to do. I wanted to record the stages of her development through life.

AJ It sounds that she is a sort of model for the development of your work.

SD Because she's a relative and I see her quite a lot, it's been interesting to paint her at various stages from when she was about two to three weeks old, up until now when she's eight. It's been more of an ongoing project for me to record her changing as she gets older.

AJ In those seven years how many times have you painted her?

SD About four or five times. The initial idea was to paint her every year, but I missed a year [giggles] so at that age the degree of change within a year, or less in some cases, is quite amazing.

AJ Almost as if it's a different person?

SD Yes. A different child. The picture of her now as an eight-year-old is incredible when I look back to the painting when she is five or six. It is just like a different person, it's amazing.

AJ If you're undertaking this work as a non-commissioned piece, as something for your intellectual and artistic practice, do you go about it differently to the commissioned portrait?

SD I'll talk about the latest painting of my niece, for instance. She was seven then and I see her quite often so that does make a difference being familiar with her character. With any kind of commissioned work, generally I only see the subject two or three times as I work entirely from photographs. It's a quite limited time you get to spend and as a result how much you get to know the subject. Not that you'll ever particularly know them very well, but you'll get an idea of them. So with the pictures of my niece, because I know her quite well I make a judgement as to what would best reflect her true nature. So, for example, in the latest picture her hair's a bit of a mess, she's dressed, not scruffily but how she would normally dress and that to me reflects her. When painting a commissioned portrait, I don't really have that much of an idea of how the child is. Obviously the parents want to reflect their children in a good light so you generally get a tidy child [laughs].

AJ I think it's very important to make a distinction between this willingness to make an assertion or to assert a certain type of judgement on your subject. As you know your niece so well you can afford to portray her in a particular way. When you don't know your subjects so well, or hardly at all, you actually almost withhold any explicit statements?

SD There is always a degree of compromise with commissions of any sort, because it's that balance between you wanting to produce a piece of work that you personally like and one that the client likes. So there are different forces at work than if you were painting for yourself.

AJ Would you only say something if you really know it to be true? You won't project or borrow from the parent an idea of how they see the child? You will only undertake what you can experience yourself?

SD Yes, I think that's the only thing I can really do. I can't really project any opinion I have about anything, because it's not really my place to do that.

AJ An untruth possibly? That's more important than a pleasing image or a satisfying of the client. You've got to experience it truthfully first?

SD I think so. Generally speaking, the portraits I've done of children that I've been commissioned to paint have been quite literal and, as a result, honest pictures of them, that are without any kind of underlying bias. Not trying to make them look angelic. Not trying to make them look disruptive, even if that was the case on the day. I've just tried to be sympathetic, but literal about it. Often there's not a lot else you can do really.

AJ Do children's portraits pose any particular problems, essentially those that don't occur in adult portraits?

SD I don't know if it's particularly a problem but there is a difference with children's portraiture or commissioned children's portraiture, because there is no input from the sitter. The child has no particular understanding, knowledge or interest in what you're doing. In fact, it's probably a fantastic inconvenience for them to have to sit still.

AJ It's almost like a still life, slightly animated.

SD Yes, it's an exercise in just being able to get a child to sit still for a bit.

AJ OK, so in that case, that being the key one, would you see any other problems? Anything else that you've experienced as being unique to that genre?

SD With a commission of an adult there is a degree of input from them about what they envisage and as a result we can spend time batting ideas back and forth. Just being able to say to an adult sitter 'Can you tip your head this way or that way?' is a straightforward and easy process, whereas with a child that's sometimes impossible to do. And on the one hand that's quite good, as with a child you'll get a more naturalistic, hopefully truthful representation of the child because they're doing exactly what they do. Whereas with an adult there is probably some degree of self-consciousness about the whole procedure. No matter how hard you try you always want to be perceived or seen in a certain way. Whereas a child is generally not interested in that.

AJ That's possibly a good thing?

SD It's quite a liberating thing in its way but just from a logistic point of view, it's very hard to sometimes engage with a child that has a very short attention span.

AJ So that makes for an elusive, slippery project that you can't quite get a grip of?

SD You can plan to a certain extent if you're doing a straightforward commission of an adult. You can sort of plan as much as you want and control it to a degree, but with a child it's pretty much a free for all until you can create an environment where you're doing the painting that the child is comfortable with. You are almost waiting for the child to become bored with the whole situation so you can hopefully get the reference photos you need.

AJ There's a bit of a waiting game where you let things settle down.

SD On a practical level I never like to paint people smiling, because it's quite a photographic device but trying to get a child not to smile, when you've told them not to smile, is difficult.

AJ Perversely wanting to get rid of a smile. That's funny in an unfunny way [*laughter*].

Knowing that you have this dual aspect in your career, your comic work inhabits a very different place in your imagination to your portrait work. Does painting portraits of children act as some sort of useful counterpoint or release from your comic work? Or does it have any relevance at all to this other side of your focus?

SD I don't know if there's a specific link between the children's portraiture aspect of my painting and the comic work. My parellel careers in portrait painting and comics perhaps have quite a direct link with the fact that in the comics there's quite a lot of figurative work which directly feeds into the portrait painting and compositionally the comic work sometimes informs the portraiture. I often look at a panel within a comic strip as a single, individual entity and sometimes this gives me an interesting idea that I can perhaps import into the portraiture.

AJ But the world of comic work that you inhabit is a world of very extreme emotional and physical realities where there's a sort of fantasy component because it exceeds the realities we normally live within. Whereas what I see with your portrait work is predominantly adult, but certainly within the children's portraiture a very refined, subtle location of emotional reality. So my interpretation is that they are utterly contrasting even if there is a literal resemblance between them, the emotional realities are polar opposites.

SD You're absolutely right. The comic work is based in a world of extremes, where expressions are extreme and there's a degree of action and a lot of cartoon violence. That's in a direct contrast to hopefully, the serenity of portraiture and the gravity that has. Comics are, and quite rightly so, quite ephemeral, brief and transitory things whereas portraiture hopefully brings a little bit more gravity to my painting career. A portrait to me represents time spent in front of another human and taking time to notice them and to compose and construct a work that will last. I consider comic art is most successful when serving the story. You are playing servant to the narrative and if you don't tell the story then you haven't succeeded. The two disciplines do feed into each other. I like both of them equally.

AJ But I see them as echoes rather than direct relationships. There is a visual correspondence carried across, to and fro. The emotional climate of these are so disparate, so exclusively different, that they appear to embody different worlds in what must be your artistic realities?

SD Yes. I think perhaps the limitations of one are made up by the other. Sometimes portraiture can be quite constrained and rather formal. The comics are quite free and they have no boundaries of reality, which I enjoy, but I also like the discipline of painting within those definite confines.

AJ So very briefly would it be fair to say they complement each other in your emotional life rather than in just your artistic production?

SD Yes. I started painting comics around twenty-five years ago or something like that and it was the first sort of art I approached seriously. I moved into the portrait painting about fifteen years ago and I found very quickly that rather than give up the comic work to concentrate purely on portraiture, I felt that I needed both in my professional career to counterbalance each other. If I were to do one discipline all the time I would have felt constrained and ultimately a little unfulfilled.

AJ Can a child's portrait be as good as a portrait of an adult? Or as artistically successful?

SD Absolutely and I definitely think it can be artistically successful. Whether or not it can be successful as a painting rather than a portrait is open for discussion. I think you can be lucky with a child's portrait and sometimes the results can be remarkable. With a successful adult's portrait, it's a very collaborative thing that has taken into consideration the fact that the adult you are painting has lived life and that is imprinted on their face, behaviour or demeanour. There is a common link between painter and subject as there is a shared experience of being an adult. However, a child, to a certain extent, is an unknown and a child doesn't understand the painter and the painter doesn't fully understand the child. They are fresh and new to the world and therefore unhindered by cyniscism and

worry. As a result, it isn't always appropriate to introduce serious and introspective content that often is depicted in portraits of adults.

AJ So is that in a way saying, all things considered equal, 'No'. A child's portrait can't reach the summit of a great adult portrait? As a work of art?

SD I don't know if that's entirely true but it's this unusual thing of a portrait transcending from being just a portrait to being considered a great painting. What makes it like that? Some of the most famous portraits or the most successful portraits I should say, are not technically brilliant or of an inspiring subject matter, but there's something about them that makes them a great painting. That is a difficult thing to pinpoint really. At the moment I'm struggling to think of portraits of children that are great paintings, other than the James Guthrie one I mentioned earlier. In my eyes it's a great painting. Whether or not it's a great portrait of a child I don't know. It's a great social comment on being a child at that time and that place. However, I do consider George Clausen's *The Girl at the Gate* to be a truly great painting.

AJ It's a very important distinction to make. A very valid one. So in a way listening to your answer I get the sense that there is some reluctance to actually say yes. There may be really impressive paintings but in terms of a classical portrait of a child the examples of them matching this summit or the height of achievement for adult portraits, the examples are few and far between.

SD Yes I think so. I'm thinking about child's portraits off the top of my head and very quickly Sergeant's name crops up because in most disciplines of portraiture, his presence is felt. Whether directly or indirectly. Some of his portraits of children are particularly beautiful whether or not they transcend into brilliant works of art or just simply remain technically brilliant pictures. They also are, generally speaking, of children of a certain class within that society and as a result don't offer me any kind of connection that resonates with me.

AJ We're not necessarily dealing with psychologies so much here. I would cite something like Rembrandt's painting of his son, Titus, or Velásquez's paintings of Infantas as some examples that come to mind of the psychology of a particular child in a particular time and place

that does exceed its generic or stereotypical treatment and becomes a real, discernible individual.

SD In the case of say, Rembrandt, because it's a painting of his son then there is that link and there is that understanding between artist and the subject. Which, in the same way if you did a painting of your wife there would hopefully be a more personal connection between the two.

AJ Listening to your answers on the previous question it's become more and more apparent that your reluctance to impose a character or personality on children highlights the difficulty to you as a painter and to actually say something about the individual's character. Quite often the best portraits of children are ones where they're not endowed with an individual personality but they're put in a context so they play a part but they're not exclusively the reason or the meaning of the picture. Where you do find successful examples of it is where the person is particularly close and knowledgeable of this individual. so a son, a child or a close family member. So I put it to you Simon, what you make is the most incredible work when you know somebody and you can tease out meaning, but you're very reluctant to say much about a child that is a commissioned subject?

SD Yes, I would agree with that. I think generally that rule pretty much applies in most commissioned portraiture really. When you've got a definite connection to the subject you always bring something a little bit more tangible to that, than you would if you weren't to know the subject and it was a commissioned piece. It's slightly unusual with children because it's a commissioned piece, not by the sitter. The sitter has no hand in it. You're often commissioned to either mark a birthday, a retirement or a marriage or some other such occasion. Whereas with a child it's purely the marking of an age. The age of that child. Because there's no intention on behalf of the sitter and the sitter is purely passive in the whole procedure, it's often very hard to attach the kind of gravity that you would if you were painting someone who is either very close to you or an adult. I wanted to paint my niece, Sophia, because she's very close to me and is part of my life. You become very fond of your family, and the to-ing and fro-ing of her growing up and my memory of it is all tied up in that picture. You have a full knowledge of the background of the child's existence, so you bring that to it. Hopefully you distil it down to a single image that best

describes what that child is.

AJ Because this particular picture of your niece is in a sense a very spartan, pared-back image with some particularly salient characteristics like slightly dishevelled hair, it acts as a signifier of the picture's meaning. You've asserted a particular quality to her which I guess you wouldn't do if it wasn't your niece?

SD Yes, absolutely. When I took the reference photographs for that particular portrait, she'd been playing out in the garden, she'd come back in and we'd managed to bribe her with sweets and whatever to come in and grace us with her presence. She was there and my sister was asking if she should comb her hair and get her to put on a neater T-shirt. I said no as I just want to paint her exactly how I see her and remember her and when I think of her that's hopefully the image that I wanted to show. Whereas if it was to be commissioned it would have to be pretty understanding parents who would allow me to just paint the child as they were.

AJ I suspect quite a bold judgement on your part to allow that or to request that. I suspect you wouldn't even request her hair to be left if it wasn't somebody you knew as well as your niece. You'd probably allow for that representation of the child. You wouldn't know that it was a quality that you wished to keep. From knowing your niece for so long you knew the qualities that were so important to keep.

SD Here again it's just a general compromise, not in a negative way, but in fulfilling the aspirations of the portrait for both myself and the client. You have to understand, generally speaking, that my desire to do a painting that has a degree of authenticity is sometimes at odds with what the parents would want. So I just have to come to an understanding between the two of us. I do understand that my ideas for a composition and treatment are often at odds with the parents'. But then I do want everybody to be happy with the whole situation.

AJ A difficult equation to manage? As this case identifies, insisting the hair is not brushed may be at odds with all parents who would commission a portrait of their child. The very fact that it's success is based on the reality that would hardly ever be allowed to occur.

SD That's true. Also with children, when they're

recorded, be it with photography or another medium during their growing up, the parents generally just encourage the child to smile. So to ask the parents to let you paint their child unsmiling, might suggest to a viewer that the child is not a happy one. It's counter intuitive. Parents want their children to look as if they're happy which is quite understandable but not smiling doesn't mean that you're unhappy. Smiling is an instant response and something I associate with holiday snapshots and as a result is lacking in the gravity and longevity that a painted portrait strives for.

AJ Treacherous for the artist, essential for the parent!

SD Exactly!

March 2016

Part Two

AJ With the image of Haydn, did you have a specific reference point that you derived the composition from and did you have any pre-existing image in your mind before you composed it?

SD The thing that became most apparent when I visited Haydn was that I wanted his home to be part of the background. Once I'd looked round the house and garden I decided that I really liked the vertical wrought-iron work at the back of the house so was very keen to introduce that into the composition. I thought it would make for a strong vertical image with the brickwork and window and so on, so it became apparent to me that I wanted to do a portrait of Haydn standing up... a full-length figure piece.

AJ It seems successful to me because there's a interaction between the architecture of the building and the 'architecture' of Haydn because of the design on his shirt, the layering and semi-abstract flatness of those design elements all working to unify and to harmonize, so was that explicitly your intent or was it just a happy outcome?

SD I think to a large extent it was just a happy accident

really as I had no idea what Haydn would be wearing before I arrived. It was summer so I imagined he would be in shorts and things like that, as I knew from having spent time with the family before that he's a pretty out-door kind of lad and is always playing out in the garden. I therefore predicted that he'd be in shorts, barefoot and pretty relaxed. His mother contacted me before I started the portrait to see if I wanted him to be dressed quite smartly but I said he must be dressed just how he would normally and, pretty much like the painting of Sophia, I wanted him to be looking like 'he does' really as opposed to making it too formal.

AJ You've certainly avoided any sort of cliché of formality entirely but for me you've created a sort of idyllic image nonetheless. It avoids any overtly sentimental quality but there's still flowers, there's still foliage and there's a sort of youthful perfection about it so I think that's a masterly piece of depiction. Would those flowers, for instance, be intentionally placed above his head to add a sentiment or a nod towards the idealistic and the beautiful?

SD I think so. I think we've discussed this before but it's very easy to slip into a kind of sentimental treatment of children which I try to avoid. In this case, the family, who have been friends for a long time, live in a house in rural Worcestershire and it's a very beautiful and relaxing place so I wanted to represent that a little in the portrait. I grew up not far from there too and my childhood was pretty much all about messing around in nature... gardens and fields... and I wanted to reflect that and also to use part of the house to ground Haydn to his home as well.

AJ So in a sense, would it be fair to say that although you wish to avoid that sort of negativity associated with a false and indulgent sentimentality, you still wanted to acknowledge that nature and beauty in those forms had a legitimate part to play in the depiction of the boy?

SD Yes. Certainly it's what I equate with childhood and growing up in a small village but I absolutely didn't want do anything cheesy like Haydn smelling or holding a flower... that would have been a step too far!

AJ Yes. Holding flowers has a great art history of renown because they are often held as emblems in an allegorical way.

SD Yes. To denote purity and things like that. Particularly their use in mid-Victorian times was sometimes a little bit hard to take.

AJ It can appear to be an odd reinvention of what is part of a pagan or ancient world... pre-scientific in many ways but I still think the power of it resonates through. I'm still trying to work out why your painting isn't sentimental in that sense and think maybe the key element that changes the nature of your depiction of reality, and therefore the portrait, is the reflection of the foliage in the window which has a sort of hard, truthful realism about it that gives the crispness that says that this is not self-indulgent. This is a bit of analytical observation as well.

SD As you say, I did want it to be a crisp portrait and have an informality about it. I wanted Haydn to look, not exactly surly, but a little bit sort of irritated that he'd had to stand for this portrait when he could be out playing or looking into a pond or something like that. He looks a little bit frustrated and is almost edging his way out of the picture.

AJ Ha!... There's a slight itchiness to get away. I'd also say that he's got a slightly elevated position and is looking a little bit above and beyond you or the viewer. So there's a sort of comfortableness in his look that empowers him.

SD I hope so. With luck, it reflects that he loves his home and where his garden and feels very comfortable and safe there.

AJ I think you have represented it very successfully and again it reinforces how sensitive and subtle a portrait painter can be when dealing with this kind of subject.

SD Well that's good to hear as I intended it to be constructed in such a way that on a basic level it was a good, honest portrait but I also wanted it to be slightly more layered and open to interpretation and a degree of narrative.

AJ OK. I really want to talk about your small portrait of Luke now so can you tell me why you did it on a technical basis and also on a content basis too?

SD Luke, like the other subjects featured in this book,

is the child of friends of mine and is a lovely and cheerful little lad so I wanted to do a small picture of him that reflected his energy and enthusiasm. I had the idea that this could be conveyed if I painted the portrait in a quick and energetic way too. Luke is a bright and engaged two-year-old and I really wanted to try and capture this. The longer I have worked as a painter, the more I become attracted by the idea of simplicity. The simplification in this case was painting with a very reduced colour palette of Burnt Umber, Yellow Ochre, Burnt Sienna, Titanium White and Prussian Blue and really sticking tightly to that discipline. In some way, I felt that this uncomplicated could perhaps the simplicity and lightness of the subject. Here again though, I didn't really know what I was going to do so made a quick initial thumbnail sketch. This sketch was based on the idea that Luke could perhaps be sitting in a chair... but as what happens with most plans that I have for portraits, and particularly those of children, within five minutes those plans have gone down the plughole. In the room that I was to take the photographs, there was great natural light and a very calm atmosphere so I had high hopes that I would be able to get what I needed without too much pain. Almost instantly, Luke became fascinated by an aerobics ball that was in there and we just couldn't prise him off it from that moment.

AJ He is a genius.

SD [*laughs*] Yes! He is a genius! He knew exactly how he wanted to be represented so who am I to try and force him to sit in a boring old chair...

AJ Quite so, how dare you get in the way of his plans for immortality!

SD Exactly!

AJ So in a sense you outline your expectations and hopes but also maintain a flexibility and capacity to carry those ideas across to another scenario because they can be scuppered at any moment.

SD Yes. Sometimes, and this is a very nice part of the process, having to adapt to your crumbling plans often throws up something much better and more interesting which is exactly what happened in this case. It's a good

lesson in trying not to be too controlling... and to trust that things often turn out better than you had planned.

AJ That's a key gift to the designer or artist. To trust that an idea is just the beginning and allow the fluid nature of things to seemingly interrupt it, and bring about a heightening and an improvement by another route. So would you say that things more often work out that way?

SD I definitely think so and that is probably the way it should be. Generally speaking, most portraits are a collaborative affair but with children that's not often possible because they have no particular understanding of what's going on. If something suggests itself to them and holds their interest that usefully reflects how they are at this particular time in their growing up so it almost seems like a more honest portrait to capture.

AJ I guess that establishes an authenticity to the moment that you're with them because they are present and engaged and it's very vivid because of that.

SD I think the thing is to be open to the 'happy accident' route. To go back to the portrait of Luke with the ball, because this object was quite large and he's only a little lad, he could lean on it and the curve of the ball made a really interesting shape compositionally. It almost takes up a third of the portrait image, so as I'm quite interested in creating basic shapes within pictures, I thought it made for a potentially a very interesting solution.

AJ I think this is a delicious composition and a piece of understated dynamic work. You have some very flat, broad geometry going on. The arrangement of these shapes has a very energetic thrust but with a very simple treatment. So essentially it's 70 per cent abstract yet within that are passages of figurative description and psychology which is so subtle and sensitively rendered that I think that those two extremes continually heighten each other. The more you comprehend one, the more you experience the other. The route of its success is its oppositional quality the clarity of expression and secondly the ambiguity of that expression and the compression of the hands is quite a mystery.

SD That's very kind of you to say! After I'd taken a lot of

photos, and I do mean a lot, I came across this pose and there was something very absorbing about it. His expression was not overtly happy but contained an ambiguity that seemed truer somehow.

AJ He's leaning forward and engaging yet he's protected by the ball. There are contradictions and intrigue about it that gives it a little complexity.

SD I think so. Because my treatment of this portrait was very quick, it was started and finished within five hours, I wanted it to have that geometric element as you mentioned. As I use these square brushes I was able to make parts of the painting quite abstracted and the ball helped with that kind of approach to it. The ball in itself is a very strange and almost bizarre shape to be in that picture.

AJ You've put a spherical object in yet it's strangely not quite settled so there's a potential for an imbalance and that gives it a feeling of slight tension.

SD I was really just trying to do a portrait of a child that wasn't consciously obscure or perverse, and to be blunt, that the parents would like. More importantly though, I simply wanted to make a picture that was just, well, interesting. I think every painting has a duty to not be boring. You see a lot of work that you think, 'Well that's one of those,' and you feel like you've seen it a million times before.

AJ All painters should realize that the key to a successful image is that your preparation and your selection is 90 per cent of what this picture will become. The success in Luke's portrait is the balance of expression, composition and treatment. All anticipated beforehand.

SD To me it's very important. To me, the paintings that I like and admire are the ones where there is a lot of thought involved. There are a lot of very good painters but not all of those really think about what they are doing and compose things in a way that is bold or unexpected. Painting portraits of children is one of the most common forms of commissioned portraiture as generally speaking, parents like to record their child growing up in a form that has gravity and longevity. It's important that, as an artist, I approach a commission like this with the intention that I can create a work that stands as a good piece of art in its own right, regardless of subject matter. To avoid an obvious solution that I have no passion for and is simply going over well-trodden ground. With a bit of luck, my ideas and the parents' hopes for a good portrait will coincide. There is a reason why I wanted to be a painter and even though the financial imperative is ever present, I feel that I mustn't become a painter that simply paints to please others... each new portrait must have the potential for growth and exploration as a painter.

AJ It is a very common portrait request so can therefore become slightly onerous and generic and is never accompanied by the artistic principles of invention and the generation of credible artistic ideas. As you say, that wish to try and achieve more than just a regulation piece is about the discipline and standard that you apply to your work, full stop. They need to function and succeed on other levels as well.

SD If you go down the road of simply trying to please the client without testing your artistic brain, everyone will be happy apart from you. You're being commissioned for the skill you have so should remember that and allow yourself to build on it.

AJ As we are discussing portraits of children at the latter stages of this book, could you tell me whether after painting the portraits for this book, your perception or feeling towards painting children has shifted a little or has fundamentally changed since you started writing the book?

SD Ooh, that's a good question! I've never minded painting children and would say that a large part of my commissioned work has been just such portraits. Because the paintings for this book are non-commissioned and are of subjects known to me, it's been on my own terms completely so they have satisfied my compositional requirements for painting. Perhaps, if they had been commissioned, I would not have been brave enough to find the solutions that I did. For example, the portrait of Sophia is quite a stark picture and even though my sister and husband really love the painting, I don't know whether I would have defaulted to something that I'd know would be a little more straightforward. But because that painting is stark and succinct I consider it a 'painting' rather than simply a portrait of my niece, if you see what I mean. Funnily enough, when that portrait was exhibited, I had a lot of really positive feedback, which leads me to think that there is definitely a way to navigate a way to a

solution that is satisfying for all concerned.

AJ Sort of like 'Unto thyself be true'! It's essential that you must try to trust your pure artistic responses and retain the integrity of your work.

SD Yes. It's realizing your role in the process or portrait painting. You are being asked to provide a service but you are also being asked because of the skill, decision-making and knowledge that you have accumulated over time.

AJ Less of a dialogue and more of a monologue...

SD Yes... ideally I would want a painting that everyone is happy with but above all, I must like it and trust that, because I do, the client will like it as well. In my experience, however, all the parents of the children I have painted have been a really good influence on the whole process and have brought a lot of positive input to the portraits' progression.

AJ These requirements sounds like they have reached the right balance in your work. An equilibrium.

SD Yes. Doing this book has been a particularly interesting experience in a lot of ways. I've found the writing side quite demanding as it's not my usual means of communication. If I was a writer, I would write instead of paint. Writing about something that doesn't use words has been quite tricky as a lot of the hundreds of decisions you make while painting are completely unconscious and are therefore hard to articulate in words. It's been difficult yet very rewarding because a little bit of self-analysis is always a good thing. I feel that I've used a part of my brain that I haven't used since school.

AJ Absolutely. It doesn't do any harm to ask these questions, though whether one is capable of complete honesty is another thing.

SD True. I've tried to write a book that is accessible and informal in approach. It is tempting to mythologize the life of a painter as you do feel that the mundane truth that painting is mostly perspiration rather than inspiration is not what anyone wants to hear [*laughs*].

August 2016

I hope that this book has gone some way to give the reader an idea as to how I approach my portrait work. I apologize if it may seem simplistic in parts and whimsical in others. This is probably down to writing not being my first language.

Writing about myself and my process was quite a challenge as most decisions made during the creation of a portrait are unconscious and intuitive. That's not to say that my painting isn't thought about but after a while painting, like most things, becomes instinctive so having to write about the stages was something that I've never had to do.

I've always admired artists who have the ability to put their thoughts into words without over-intellectualizing the subject and alienating the reader. I was keen to try and do the same. It turned out to be a most rewarding and enlightening experience for me and I found the whole process very useful.

I believe a healthy artist should constantly go through a process of re-evaluating and re-analysing their development so writing this book has had a similar effect for me.

What I wanted to put forward is an approach to painting that is both joyful and not too precious. Saying that, portraiture and children's portraiture in particular is often not for the faint-hearted and there are many traps laid along the way.

With a bit of thought and preparation, any problems can be navigated around and work can be produced that is successful both artistically and commercially.

Further Reading

Bajou, Valérie, *Eugène Carrière* (Acatos, 1998)

Billcliffe, Roger, *The Glasgow Boys* (Frances Lincoln Limited, 2008)

Gallati, Barbara Dayer, *Children of the Gilded Era* (Merrell, 2004)

Jenkins, Adrian, *Painters and Peasants* (Bolton Museum and Art Gallery, 2000)

McConkey, Kenneth, *George Clausen and the Picture of English Rural Life* (Atelier Books, 2012)

Nebehay, Christian M. *Egon Schiele: Sketch Books* (Thames and Hudson, 1989)

James, Andrew and Paul, *Painting Self-Portraits* (The Crowood Press Limited, 2015)